CELEBRATE AMERICA

IN POETRY AND ART

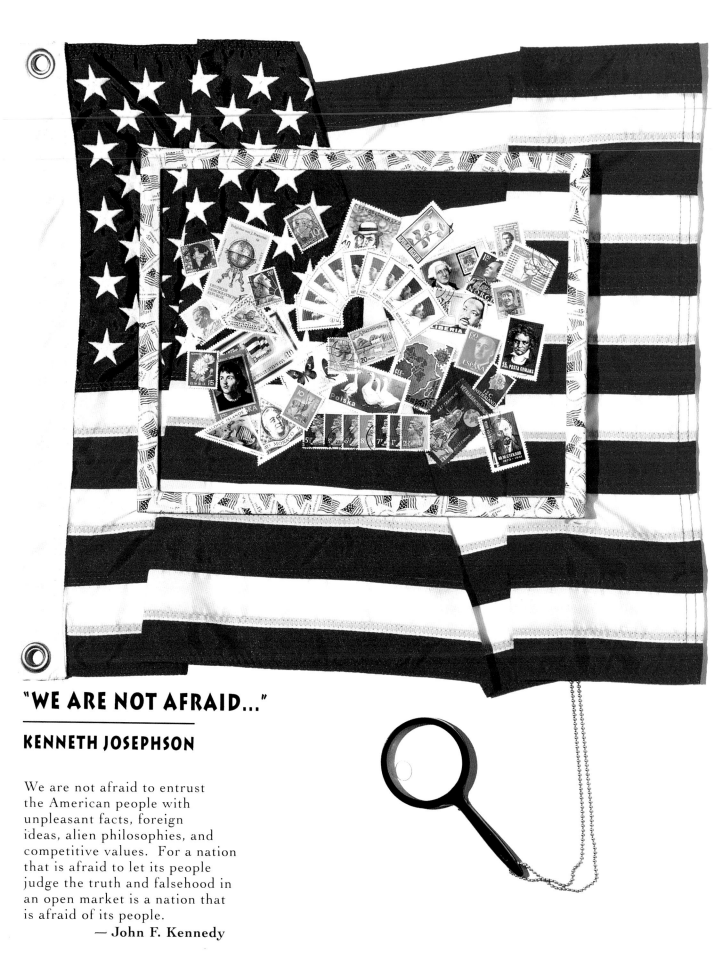

"WE ARE NOT AFRAID..."

KENNETH JOSEPHSON

We are not afraid to entrust the American people with unpleasant facts, foreign ideas, alien philosophies, and competitive values. For a nation that is afraid to let its people judge the truth and falsehood in an open market is a nation that is afraid of its people.
— John F. Kennedy

CELEBRATE AMERICA
IN POETRY AND ART
EDITED BY NORA PANZER

PAINTINGS, SCULPTURE, DRAWINGS, PHOTOGRAPHS, AND OTHER WORKS OF ART
FROM THE NATIONAL MUSEUM OF AMERICAN ART,
SMITHSONIAN INSTITUTION

PUBLISHED IN ASSOCIATION WITH THE
NATIONAL MUSEUM OF AMERICAN ART, SMITHSONIAN INSTITUTION

HYPERION PAPERBACKS FOR CHILDREN

NEW YORK

FOR DAVID, JOANNE, JAMIE, AND CAROLYN

ACKNOWLEDGMENTS

I wish to thank Elizabeth Broun, director of the National Museum of American Art, and Steve Dietz, chief of publications, for their encouragement of this project; Melissa Hirsch, museum editor, Debbie Thomas and Claudine Tambuaco, museum editorial assistants, for helping to bring this book to fruition; and the museum's curatorial and education staffs, along with those docents and interns, all of whom have given generously of their time.

— N.P.

 Smithsonian
National Museum of American Art

3 5 7 9 10 8 6 4 2
Library of Congress Cataloging-in-Publication Data
Celebrate America: in poetry and art/edited by Nora Panzer-1st ed.
p. cm.
"Published in association with the National Museum of American Art, Smithsonian Institution"
Includes index
Summary: A collection of American poetry that celebrates 200 years of American life and history as illustrated by fine art from the collection of the National Museum of American Art.
ISBN: 1-56282-664-4 (trade)-ISBN 1-56282-665-4 (lib. bdg.)-ISBN 0-7868-1360-1 (pbk.) 1. America-Juvenile poetry. 2. Children's poetry, American. 3. United States-Juvenile poetry. 4. America in art-Juvenile literature. 5. United States in art-Juvenile literature. [1. United States-Poetry. 2. American Poetry-Collections. 3. United States in art.] I. Panzer, Nora. II. National Museum of American Art (U.S.)
PS595.A43C431994
811.008'03273-dc20 93-32336

The National Museum of American Art, The Smithsonian Institution, is dedicated to the preservation, exhibition, and study of the visual arts in America. Its publications program includes the scholarly journal *American Art*. The museum also has extensive research resources: the databases of the inventories of American Painting and Sculpture, several image archives, and a variety of fellowships for scholars. The Renwick Gallery, one of the nation's premier craft museums, is part of the NMAA. For more information or a catalog of publications, write: Office of Publications, National Museum of American Art, Smithsonian Institution, Washington, D.C. 20560.

CONTENTS

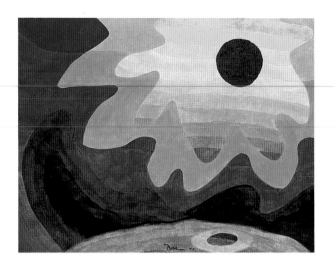

SUN

ARTHUR DOVE

PREFACE

By paying visual and poetic tribute to the shared experience of the American people, past and present, this book celebrates America. Today, when our country is more ethnically diverse than at any other time in history, there is a great need for us to be aware of America's unique cultural heritage.

It is fitting, then, that we turn to our nation's poets and visual artists to chronicle the events, rites, and rituals we share as Americans. The works of art and poetry in this book were chosen to represent both genders as well as a range of ethnic groups, social and economic classes, regional styles, and historical periods. The paintings, prints, photographs, and folk art do not merely illustrate the poems, nor do the words of the poems merely explain the pictures. Together they form a kind of synergy, creating a complementary way of expressing, with joy or sorrow, longing or despair, sensuality or reason, humor or anger, the dynamic rhythms of American life.

Walt Whitman, one of the greatest poets to celebrate America, holds a special significance for the National Museum of American Art. During the Civil War the building that now houses the museum was used as a makeshift hospital, and it was here that Whitman came to tend the wounded and to read his poetry in the evenings. More

than a century ago he wrote words that eloquently express the intention of this book and have inspired me to marry poetry and art in a collection: "The Americans of all nations at any time upon the earth," he said, "have probably the fullest poetical nature. These United States are essentially the greatest poem."

Just as Whitman's poetry revels in all of America, Tato Laviera's lighthearted "AmeRícan," written in 1981, celebrates the pride of newly arrived Puerto Ricans and their part in the creation of yet another national identity in the barrios of bustling New York City. Laviera writes, "[W]e gave birth to a new generation, / AmeRícan salutes all folklores, / european, indian, black, spanish, / and anything else compatible."

Yet our greatest poetry can also critique as well as celebrate. It can give voice to protest or praise what has been ignored or denied. Langston Hughes lifts his voice in "I, Too" to speak about the racism and neglected promise of the American dream for African Americans. Gloria Anzaldúa, in "To live in the Borderlands means you," recounts how as a Mexican American you live *sin fronteras*, or "without borders." You carry all five races of your Mexican-American heritage on your back and are not grounded in any one. Mark Van Doren's prophetic poem "I Went Among the Mean Streets" recalls images of fear and violence, the "thieves of joy" that haunt America's cities.

Our visual artists, too, provide us with provocative insights into our society. Their treasured views of American faces and places document the appearance of our people and interpret our changing land from colonial times to the present. Helen Lundeberg's powerful image of pioneers facing west, William H. Johnson's brightly colored scenes of Harlem in the 1930s, and Norman Chamberlain's depiction of a corn dance in a Taos pueblo are just a small sample of what awaits you as you browse through this book.

The book is divided into five sections to allow us to see how poets and artists are often inspired by common experiences. There are many ways of looking at the same world and many ways of expressing intimate, personal reactions to it. The sections focus on America's natural landscapes, the lineages of its people, the building of its cities and towns, its history of struggle and protest, and the many tempos of its everyday life.

I am very grateful to have had the expert advice of Ethelbert Miller, Indran Amirthanayagam, Heid Erdrich, and Virgil Suárez. They each provided invaluable assistance in researching and selecting poetry for this book. By offering a broad sampling of the country's poetry and art, I hope to unite all readers in a shared understanding of our nation—to celebrate America.

—Nora Panzer

Chief, Office of Educational Programs
National Museum of American Art

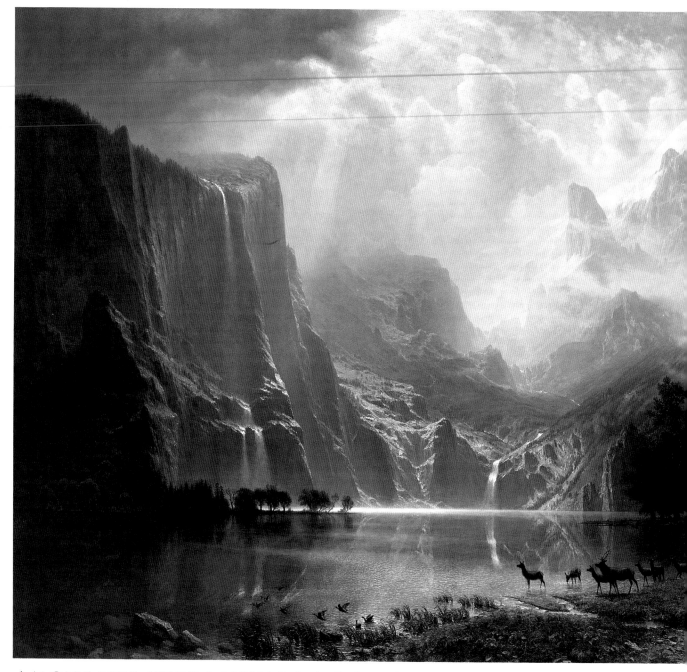

AMONG THE SIERRA NEVADA MOUNTAINS, CALIFORNIA

ALBERT BIERSTADT

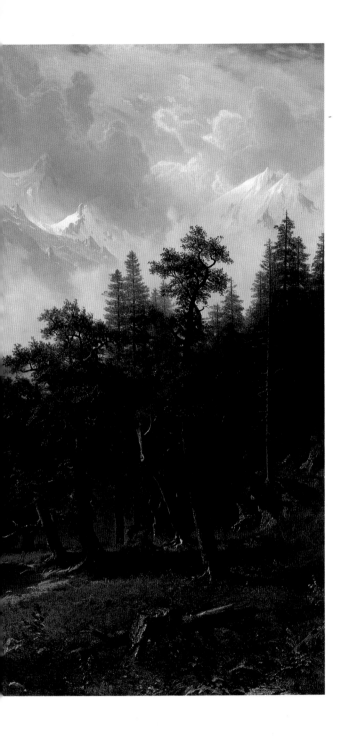

A
PLACE
OF
EAGLES

from
AMERICA
THE
BEAUTIFUL

KATHARINE LEE BATES

O beautiful for spacious skies,
 For amber waves of grain,
For purple mountain majesties
 Above the fruited plain!
 America! America!
 God shed His grace on thee
And crown thy good with brotherhood
 From sea to shining sea!

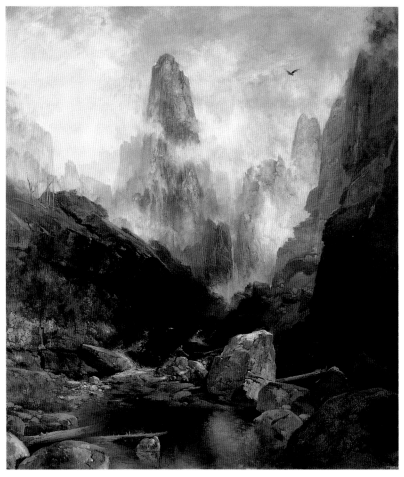

MIST IN KANAB
CANYON, UTAH

THOMAS MORAN

LEGACY

MAURICE KENNY

my face is grass
 color of April rain;
arms, legs are the limbs
 of birch, cedar;
my thoughts are winds
 which blow;
pictures in my mind
 are the climb uphill
 to dream in the sun;
 hawk feathers, and quills
 of porcupine running
 the edge of the stream
 which reflects stories
 of my many mornings
 and the dark faces of night
 mingled with victories
 of dawn and tomorrow;
corn of the fields and squash . . .
 the daughters of my mother
 who collect honey
 and all the fruits;
meadow and sky are the end of my day
 the stretch of my night
 yet the birth of my dust;
my wind is the breath of a fawn
 the cry of the cub
 the trot of the wolf
 whose print covers
 the tracks of my feet;
my word, my word,
 loaned

legacy, the obligation I hand
 to the blood of my flesh
 the sinew of the loins
to hold to the sun
and the moon
which direct the river
 that carries my song
 and the beat of the drum
to the fires of the village
 which endures.

RIVER BLUFFS, 1320 MILES ABOVE ST. LOUIS

GEORGE CATLIN

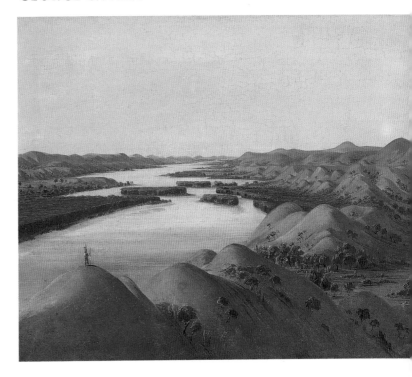

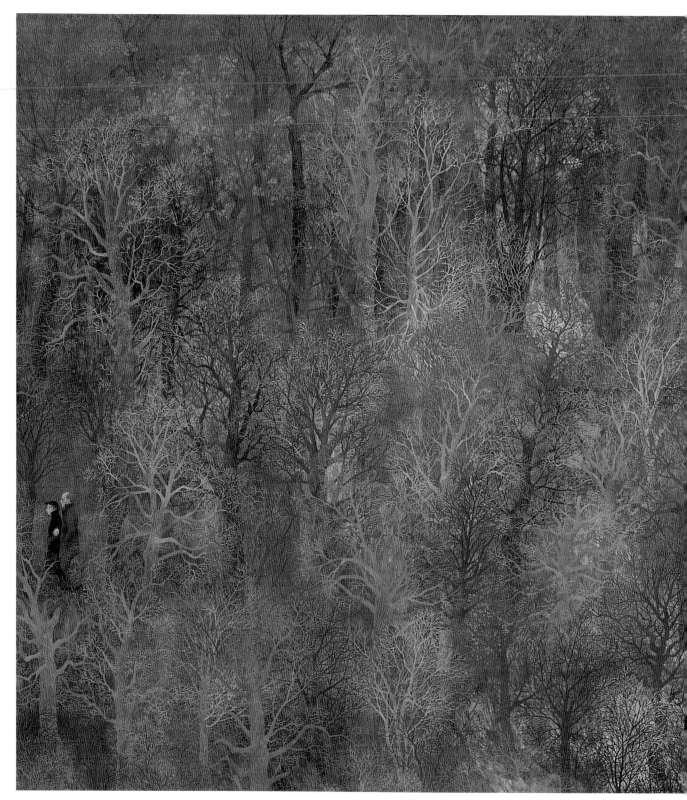

THE FAREWELL

BERNARD PERLIN

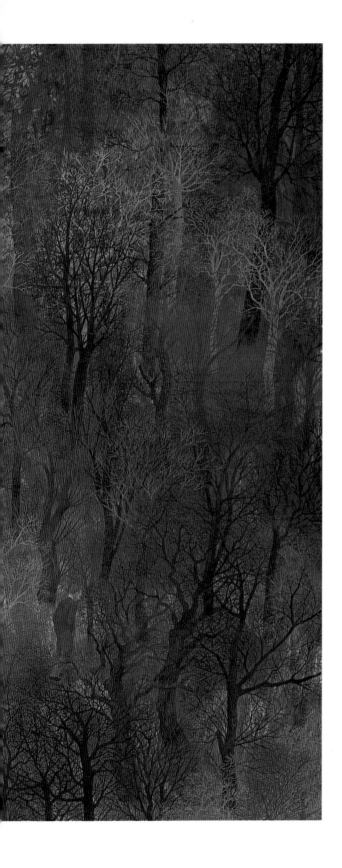

IN HARDWOOD GROVES

ROBERT FROST

The same leaves over and over again!
They fall from giving shade above
To make one texture of faded brown
And fit the earth like a leather glove.

Before the leaves can mount again
To fill the trees with another shade,
They must go down past things coming up.
They must go down into the dark decayed.

They *must* be pierced by flowers and put
Beneath the feet of dancing flowers.
However it is in some other world
I know that this is the way in ours.

NIAGARA

CARL SANDBURG

The tumblers of the rapids go white, go green,
go changing over the gray, the brown, the rocks.
The fight of the water, the stones,
the fight makes a foam laughter
before the last look over the long slide
down the spread of a sheen in the straight fall.
　　Then the growl, the chutter,
　　down under the boom and the muffle,
　　the hoo hoi deep,
　　the hoo hoi down,
　　　　this is Niagara.

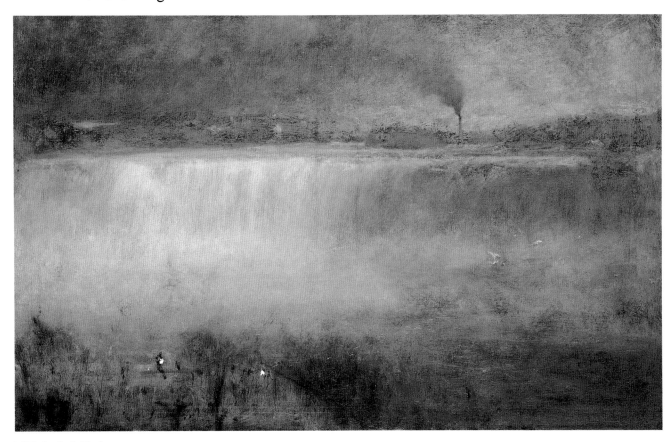

NIAGARA

GEORGE INNESS

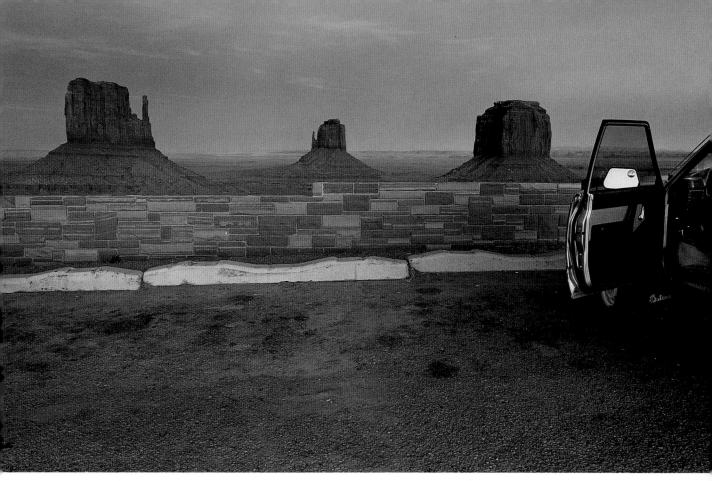

MONUMENT VALLEY, NATIONAL MONUMENT, ARIZONA

LEN JENSHEL

THE MONOLITHS

N. SCOTT MOMADAY

The wind lay upon me.
The monoliths were there
in the long light, standing
cleanly apart from time.

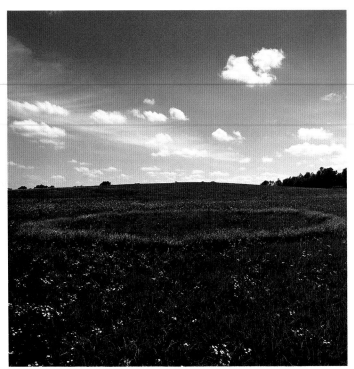

FAIRY RING #2, FENT'S PRAIRIE

TERRY EVANS

from
A DAKOTA WHEAT-FIELD

HAMLIN GARLAND

Like liquid gold the wheat-field lies,
 A marvel of yellow and russet and green,
That ripples and runs, that floats and flies,
 With the subtle shadows, the change,
 the sheen,
 That play in the golden hair of a girl, —
 A ripple of amber—a flare
 Of light sweeping after—a curl
In the hollows like swirling feet
 Of fairy waltzers, the colors run
 To the western sun
Through the deeps of
 the ripening wheat.

TO MAKE
A PRAIRIE

EMILY DICKINSON

To make a prairie it takes a clover
 and one bee,
One clover, and a bee.
And revery.
The revery alone will do,
If bees are few.

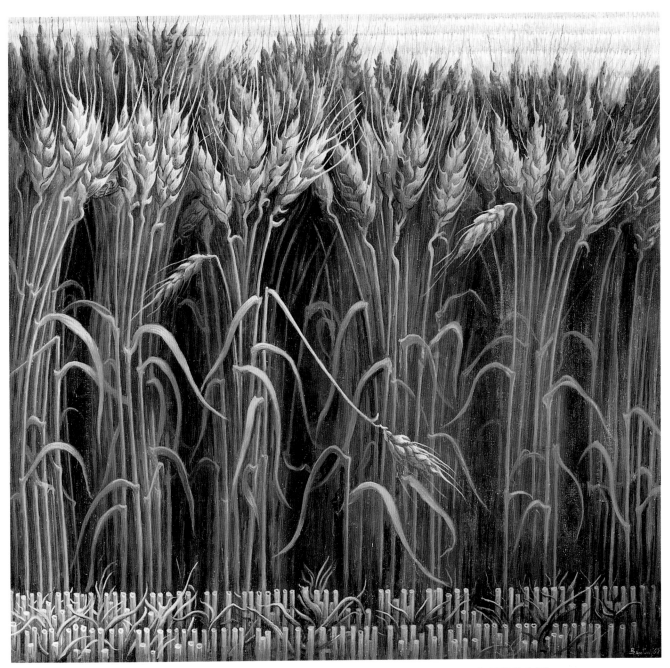

WHEAT

THOMAS HART BENTON

AT SEA

JEAN TOOMER

Once I saw large waves
Crested with white-caps;
A driving wind
Transformed the caps
Into scudding spray—
"Swift souls," I addressed them—
They turned towards me
Startled
Sea-descending faces;
But I, not they,
Felt the pang of transience.

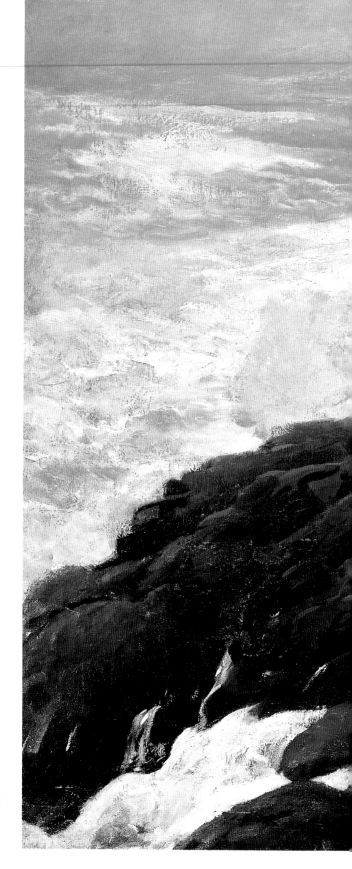

HIGH CLIFF, COAST OF MAINE

WINSLOW HOMER

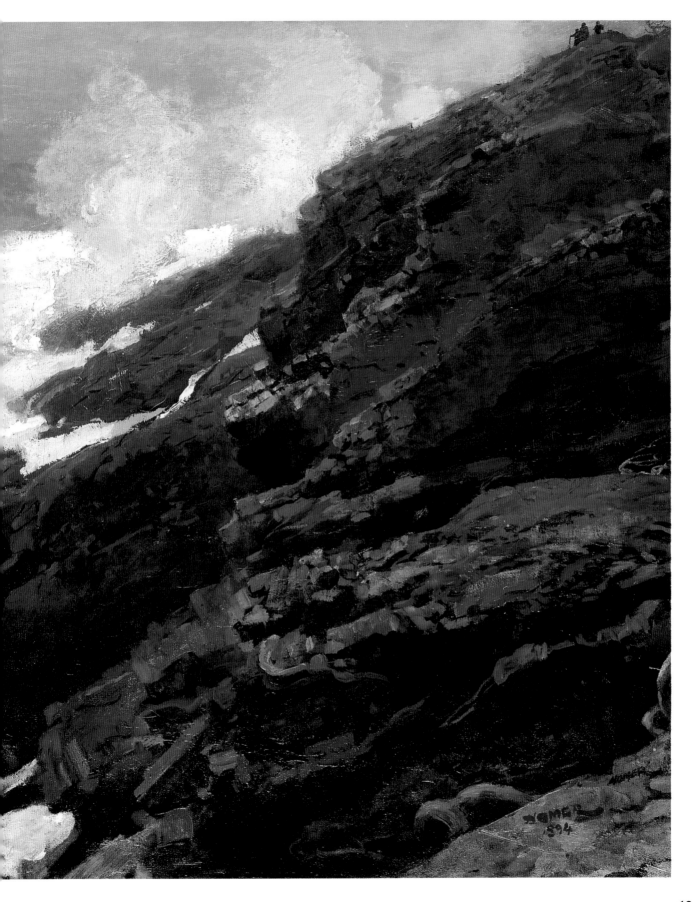

DRUMBEAT

CAROL SNOW

Listen.
There! Do you not hear them?
Come away from your overcrowded city
To a place of eagles
And then perhaps you will hear.
Be still this once;
Hold the yammering
of your jackhammer tongue.
Take your stainless steel hands
From the ears of your heart

And listen.
Or have you forgotten how?
They are there yet
Through these hundred centuries
And all your metal thunder
Has not silenced them.
The wind is messenger,
Heed the whispering spirit.
Now. . . . the drums still talk,
From the grizzly bear hills,
Across the antelope plains,
In the veins of your blood:
The heartbeat
Of the Mother Earth.

FALL IN THE FOOTHILLS

W. HERBERT DUNTON

WILD WEST

EMIL ARMIN

THE ROAD TO TRES PIEDRAS

LEO ROMERO

what a lone lonely
road
stretching out
ever winding away
with spreading fields
around it
with the vastness of an outdoor
sky around it
lonely lone road
away away
to a needle's point
on a remote horizon

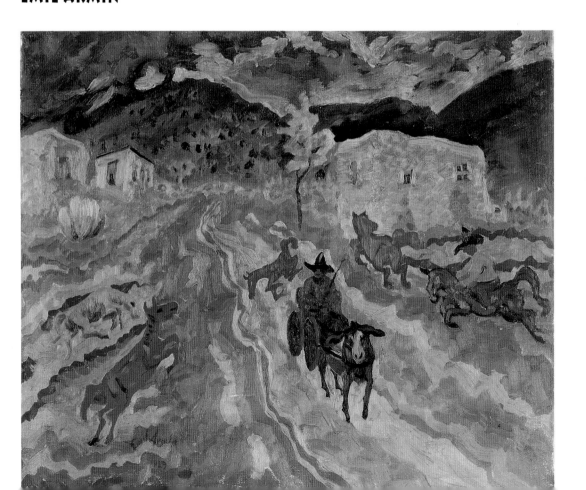

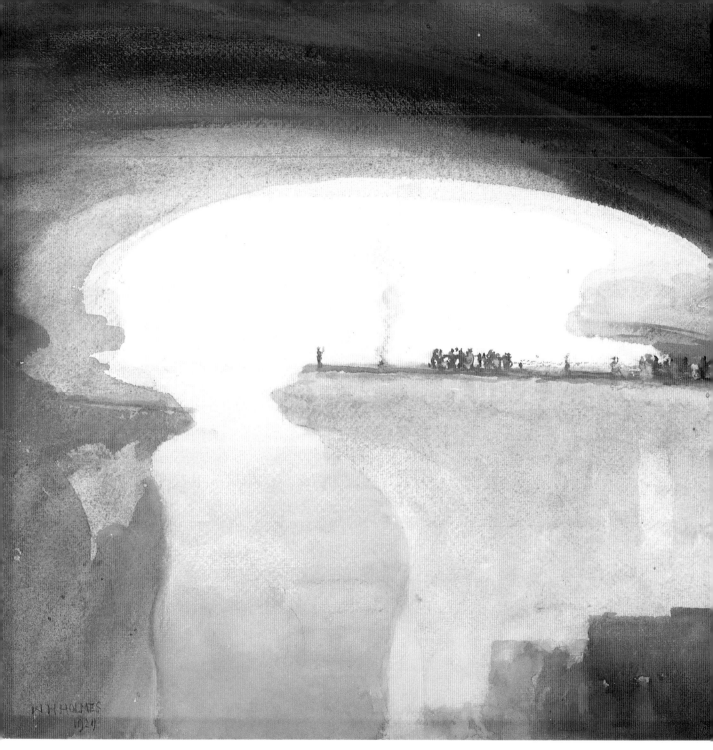

A CLIFF DWELLER'S CEREMONY, COLORADO

WILLIAM HENRY HOLMES

REMEMBER THE SKY YOU WERE BORN UNDER

EMPTY KETTLE

LOUIS (LITTLE COON) OLIVER

I do not waste what is wild
I only take what my cup
 can hold.
When the black kettle gapes
 empty
and children eat roasted acorns
 only,
it is time to rise-up early
 take no drink — eat no food
 sing the song of the hunter.
I see the Buck — I chant

I chant the deer chant:
 "He-hebah-Ah-kay-kee-no!"
My arrow, no woman has ever touched,
 finds its mark.
I open the way for the blood to pour
 back to Mother Earth
 the debt I owe.
My soul rises — rapturous
 and I sing a different song,
 I sing,
 I sing.

BUFFALO DANCE, LEADER AND HUNTER

OQWA PI

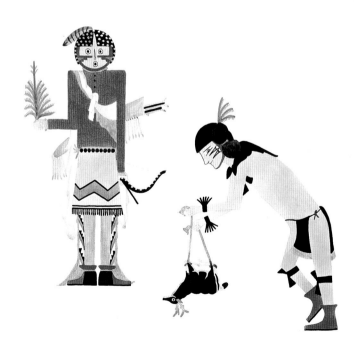

LINEAGE

MARGARET WALKER

My grandmothers were strong.
They followed plows and bent to toil.
They moved through fields sowing seed.
They touched earth and grain grew.
They were full of sturdiness and singing.
My grandmothers were strong.

My grandmothers are full of memories
Smelling of soap and onions and wet clay
With veins rolling roughly over quick hands
They have many clean words to say.
My grandmothers were strong.
Why am I not as they?

PIONEERS OF THE WEST (detail)

HELEN LUNDEBERG

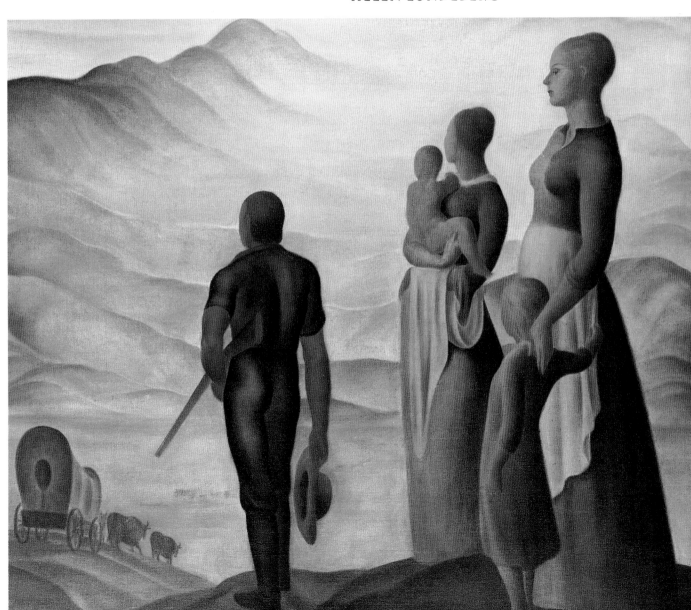

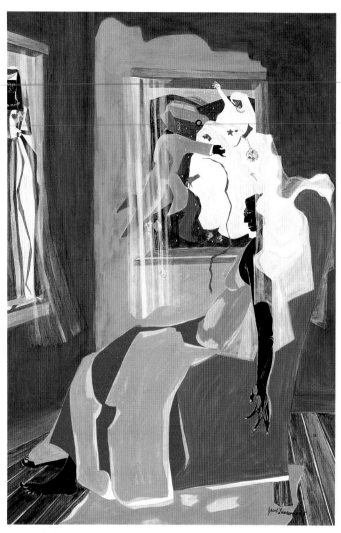

DREAMS NO. 2

JACOB LAWRENCE

DREAM VARIATION

LANGSTON HUGHES

To fling my arms wide
In some place of the sun,
To whirl and to dance
Till the white day is done.
Then rest at cool evening
Beneath a tall tree
While night comes on gently,
 Dark like me—
That is my dream!

To fling my arms wide
In the face of the sun,
Dance! whirl! whirl!
Till the quick day is done.
Rest at pale evening. . . .
A tall, slim tree. . . .
Night coming tenderly
 Black like me.

THE NEW COLOSSUS

EMMA LAZARUS

Not like the brazen giant of Greek fame,
With conquering limbs astride from land to land;
Here at our sea-washed sunset gates shall stand
A mighty woman with a torch, whose flame
Is the imprisoned lightning, and her name
Mother of Exiles. From her beacon-hand
Glows world-wide welcome; her mild eyes command
The air-bridged harbor that twin-cities frame.
"Keep, ancient lands, your storied pomp!" cries she
With silent lips. "Give me your tired, your poor,
Your huddled masses yearning to breathe free,
The wretched refuse of your teeming shore.
Send these, the homeless, tempest-tossed to me—
I lift my lamp beside the golden door!"

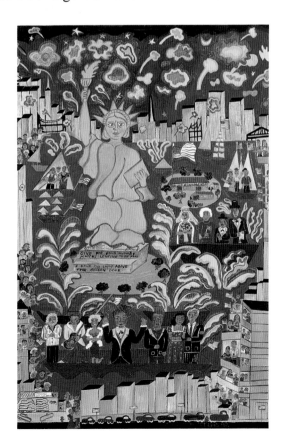

MISS LIBERTY CELEBRATION

MALCAH ZELDIS

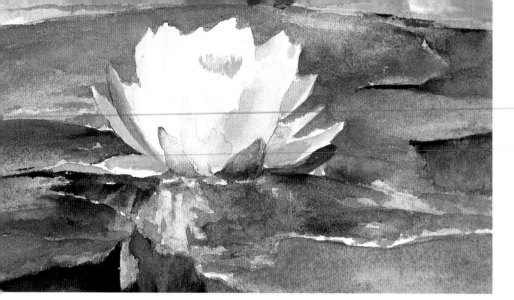

WATER LILY (detail)

JOHN LA FARGE

I ASK MY MOTHER TO SING

LI-YOUNG LEE

She begins, and my grandmother joins her.
Mother and daughter sing like young girls.
If my father were alive, he would play
his accordion and sway like a boat.

I've never been in Peking, or the Summer Palace,
nor stood on the great Stone Boat to watch
the rain begin on Kuen Ming Lake, the picnickers
running away in the grass.

But I love to hear it sung;
how the waterlilies fill with rain until
they overturn, spilling water into water,
then rock back, and fill with more.

Both women have begun to cry.
But neither stops her song.

from
AmeRícan

TATO LAVIERA

we gave birth to a new generation,
AmeRícan, broader than lost gold
never touched, hidden inside the
puerto rican mountains.

we gave birth to a new generation,
AmeRícan, it includes everything
imaginable you-name-it-we-got-it
society.

we gave birth to a new generation,
AmeRícan salutes all folklores,
european, indian, black, spanish,
and anything else compatible:

AmeRícan, singing to composer pedro flores' palm
trees high up in the universal sky!

AmeRícan, sweet soft spanish danzas gypsies
moving lyrics la española cascabelling
presence always singing at our side!

AmeRícan, beating jíbaro modern troubadours
crying guitars romantic continental
bolero love songs!

AmeRícan, across forth and across back
back across and forth back
forth across and back and forth
our trips are walking bridges!

it all dissolved into itself, the attempt
was truly made, the attempt was truly
absorbed, digested, we spit out
the poison, we spit out the malice,
we stand, affirmative in action,
to reproduce a broader answer to the
marginality that gobbled us up abruptly!

AmeRícan, walking plena-rhythms in new york,
strutting beautifully alert, alive,
many turning eyes wondering,
admiring!

AmeRícan, defining myself my own way any way many
ways Am e Rícan, with the big R and the
accent on the í!

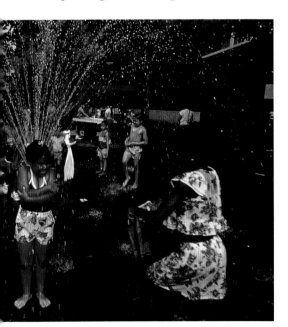

GIRL AT SPRINKLER

JOSEPH RODRIGUEZ

DAY OF THE REFUGIOS

ALBERTO RÍOS

In Mexico and Latin America, celebrating one's Saint's day instead of one's birthday is common.

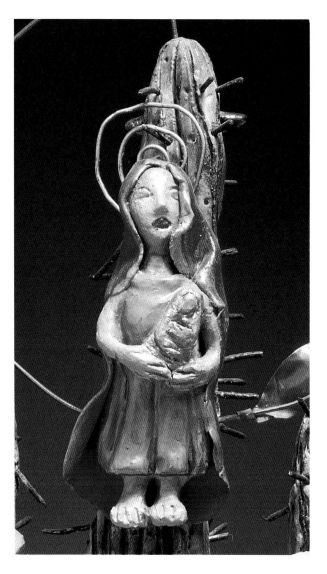

(detail, Bien Venida y Vaya con Dios)

I was born in Nogales, Arizona,
On the border between
Mexico and the United States.

The places in between places
They are like little countries
Themselves, with their own holidays

Taken a little from everywhere.
My Fourth of July is from childhood,
Childhood itself a kind of country, too.

It's a place that's far from me now,
A place I'd like to visit again.
The Fourth of July always takes me there.

In that childhood place and border place
The Fourth of July, like everything else,
It meant more than just one thing.

In the United States the Fourth of July
It was the United States.
In Mexico it was the *día de los Refugios,*

The saint's day of people named Refugio.
I come from a family of people with names,
Real names, not-afraid names, with colors

Like the fireworks: Refugio,
Margarito, Matilde, Alvaro, Consuelo,
Humberto, Olga, Celina, Gilberto.

Names that take a moment to say,
Names you have to practice.
These were the names of saints, serious ones,

And it was right to take a moment with them.
I guess that's what my family thought.
The connection to saints was strong:

My grandmother's name—here it comes—
Her name was Refugio,
And my great-grandmother's name was Refugio,

And my mother-in-law's name now,
It's another Refugio, Refugios everywhere,
Refugios and shrimp cocktails and sodas.

Fourth of July was a birthday party
For all the women in my family
Going way back, a party

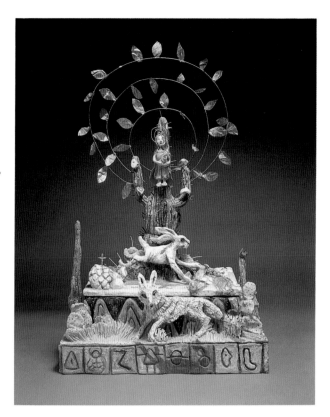

BIEN VENIDA Y VAYA CON DIOS

MARIA ALQUILAR

For everything Mexico, where they came from,
For the other words and the green
Tinted glasses my great-grandmother wore.

These women were me,
What I was before me,
So that birthday fireworks in the evening,

All for them,
This seemed right.
In that way the fireworks were for me, too.

Still, we were in the United States now,
And the Fourth of July,
Well, it was the Fourth of July.

But just what that meant,
In this border place and time,
It was a matter of opinion in my family.

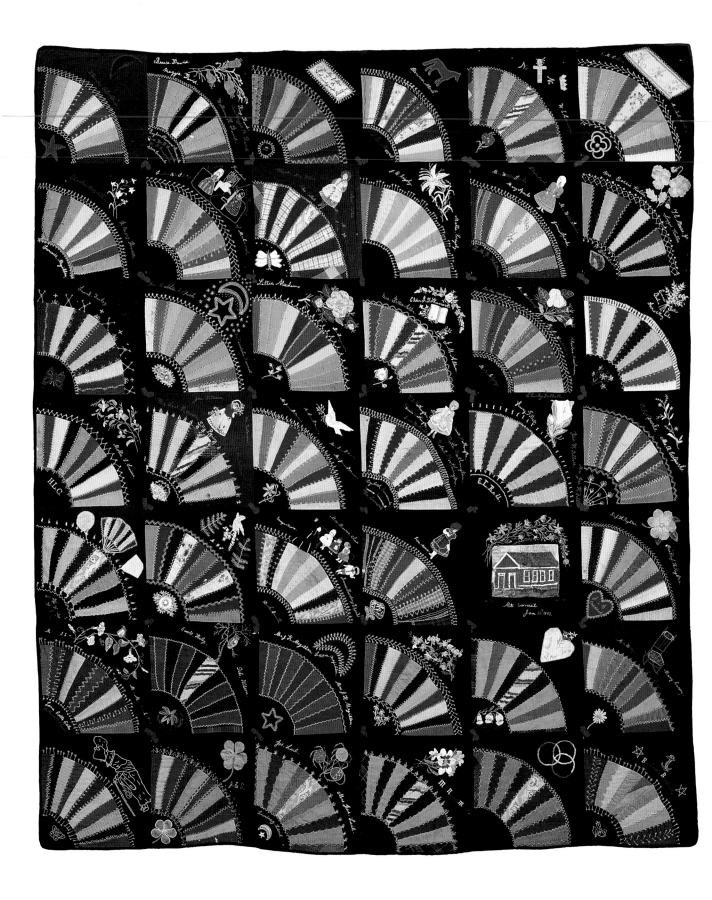

REMEMBER

JOY HARJO

Remember the sky that you were born under,
know each of the star's stories.
Remember the moon, know who she is. I met her
in a bar once in Iowa City.
Remember the sun's birth at dawn, that is the
strongest point of time. Remember sundown
and the giving away to night.
Remember your birth, how your mother struggled
to give you form and breath. You are evidence of
her life, and her mother's, and hers.
Remember your father. He is your life, also.
Remember the earth whose skin you are:
red earth, black earth, yellow earth, white earth
brown earth, we are earth.
Remember the plants, trees, animal life who all have their
tribes, their families, their histories, too. Talk to them,
listen to them. They are alive poems.
Remember the wind. Remember her voice. She knows the
origin of this universe. I heard her singing Kiowa war
dance songs at the corner of Fourth and Central once.
Remember that you are all people and that all people
are you.
Remember that you are this universe and that this
universe is you.
Remember that all is in motion, is growing, is you.
Remember that language comes from this.
Remember the dance that language is, that life is.
Remember.

FAN QUILT, MT. CARMEL

RESIDENTS OF BOURBON COUNTY, KENTUCKY

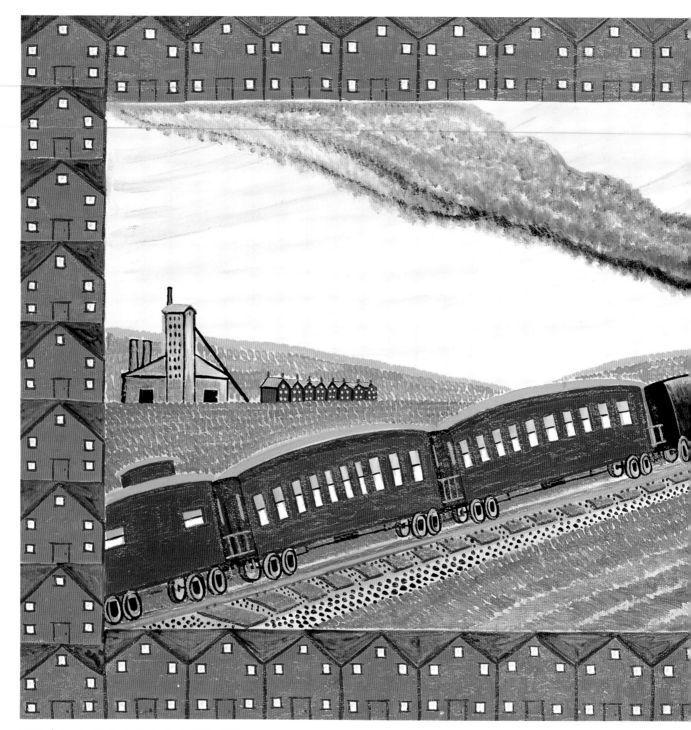

TRAIN IN COAL TOWN

JACK SAVITSKY

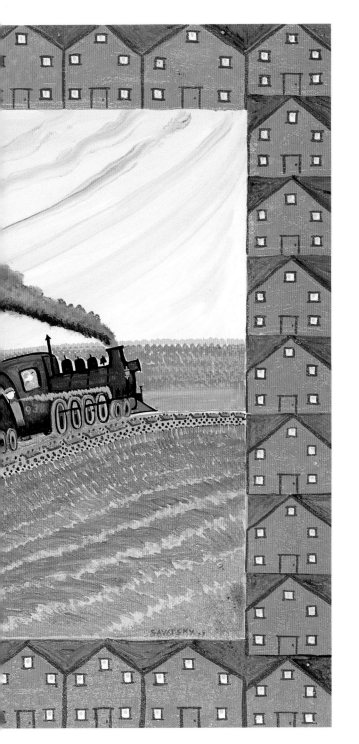

A
GREAT
PULSE
BEATING

WESTERN WAGONS

ROSEMARY AND STEPHEN VINCENT BENÉT

They went with axe and rifle, when the trail was still to blaze,
They went with wife and children, in the prairie-schooner days,
With banjo and with frying pan—Susanna, don't you cry!
For I'm off to California to get rich out there or die!

We've broken land and cleared it, but we're tired of where we
 are.
They say that wild Nebraska is a better place by far.
There's gold in far Wyoming, there's black earth in Ioway,
So pack up the kids and blankets, for we're moving out today!

The cowards never started and the weak died on the road,
And all across the continent, the endless campfires glowed.
We'd taken land and settled—but a traveler passed by—
And we're going West tomorrow—Lordy, never ask us why!

We're going West tomorrow, where the promises can't fail.
O'er the hills in legions, boys, and crowd the dusty trail!
We shall starve and freeze and suffer. We shall die, and tame the
 lands.
But we're going West tomorrow, with our fortune in our hands.

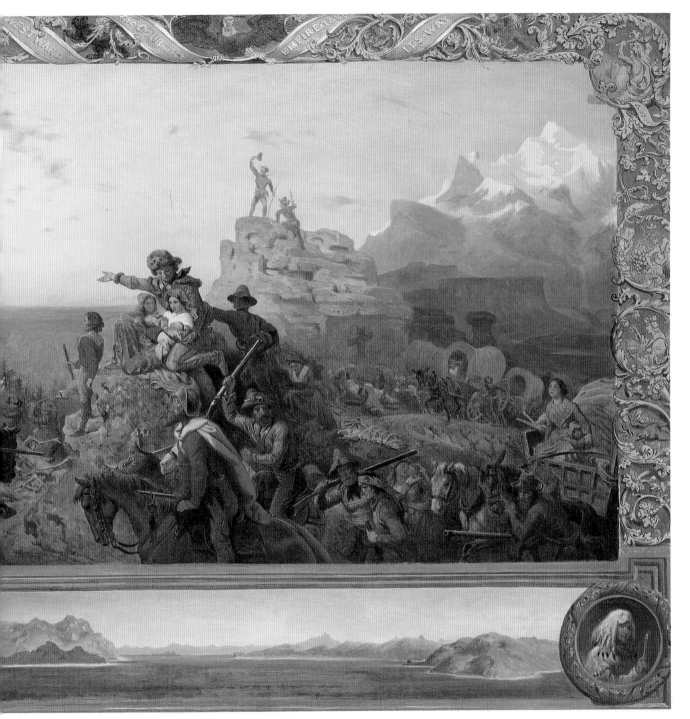

WESTWARD THE COURSE OF EMPIRE TAKES ITS WAY

EMANUEL GOTTLIEB LEUTZE

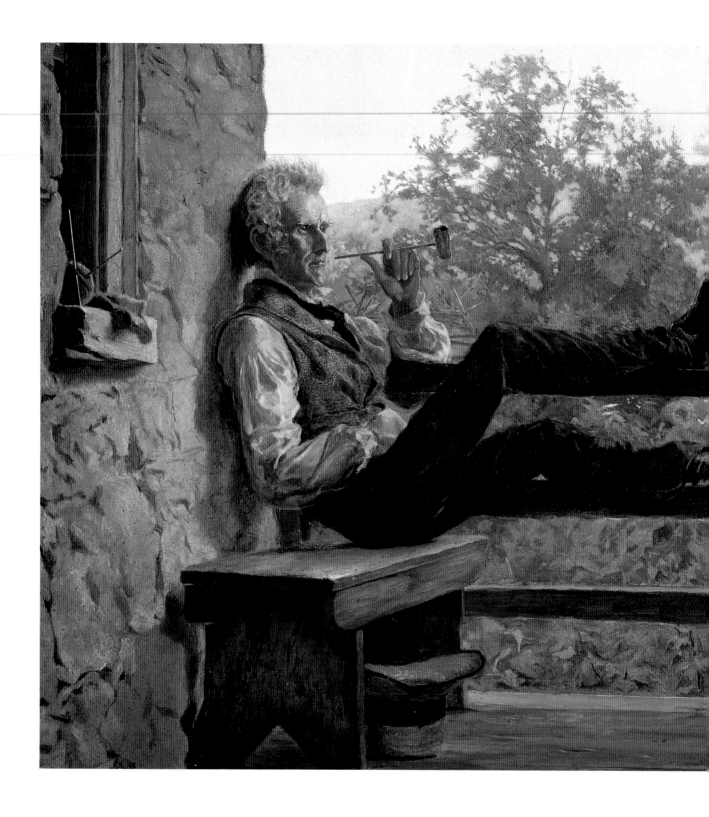

FRONT PORCH

LESLIE NELSON JENNINGS

People who live in cities never know
 The creak of hickory rockers and the hum
Of talk about what happened years ago.
 Just sitting on the sunny side of some
Old house can bring us closer to events
 Than counting seconds, though the world says not.
If looking backward doesn't make good sense
 Tomorrow, then, may be as well forgot.

Those who planned farmsteads hereabouts took time
 Enough to square a beam and see it placed
A man of sixty wasn't past his prime
 And nothing worth a penny went to waste.
We can remember many things with pride,
Who built front porches neighbourly and wide.

INDEPENDENCE (SQUIRE JACK PORTER)

FRANK BLACKWELL MAYER

from
VAQUERO

JOAQUIN MILLER

His broad-brimm'd hat push'd back with careless air,
The proud vaquero sits his steed as free
As winds that toss his black abundant hair.
No rover ever swept a lawless sea
With such a haught and heedless air as he
Who scorns the path, and bounds with swift disdain
Away, a peon born, yet born to be
A splendid king; behold him ride, and reign.

VAQUERO

LUIS ALFONSO JIMÉNEZ, JR.

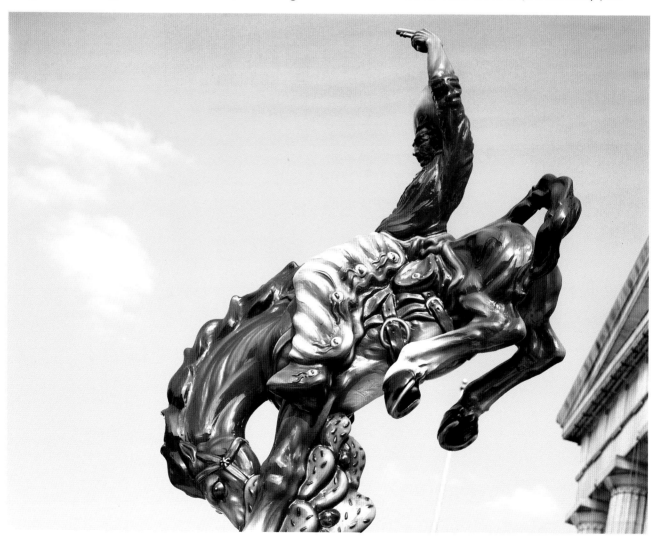

CAR ACROSS THE STREET

ARTHUR DOVE

ASSEMBLY LINE

ADRIEN STOUTENBERG

Henry had something on his mind
beyond the folderol of birds,
or horses waltzing in a field,
or loafing trees. Henry inclined
toward something practical and square,
and built it black and built it cheap
with wheels to last an average trip
(and, for emergencies, a spare).
Henry had hit on something new
to fill up dinner pails and time
and occupy men's noisy hands
and start a factory or two.

History was bunk, Henry averred
and turned a crank and set a spark,
honked at the corn and shimmied out
headlong across a neighing world;
plowed frogs and leaves and eagles under,
corrected mountains, fixed the dark,
followed a rainbow, found instead
the freeway's hot and surly thunder —
and at the end a twitching flare
like a red bush. History is junk.
Beneath, the earth is six feet deep;
the grass is optional and spare.

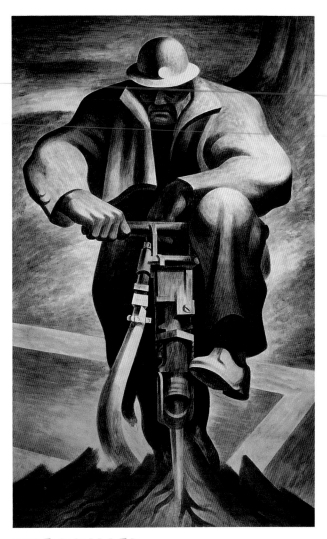

THE DRILLER

HAROLD LEHMAN

SONG OF THE BUILDERS

JESSIE WILMORE MURTON

O beams of steel are slim and black
And danger lurks on the skyward track,
But men are many, and men are bold,
And what is risk, when the stake is gold?
 So riveters ring,
 And hot bolts fly,
 And strong men toil,
 And sweat . . . and die . . .
But the city's towers grow straight and high!
O beams of steel are black and slim,
But the wills of men are stubborn and grim,
They reach forever to clutch the sun,
And what is life, if the goal be won?
 So riveters ring,
 And hot bolts fly,
 And strong men toil,
 And sweat . . . and die . . .
But the city's towers grow straight and high!

BUILDING

GWENDOLYN BROOKS

When I see a brave building
straining high, and higher,
hard and bright and sassy in the seasons,
I think of the hands that put that strength together.

The little soft hands. Hands coming away from cold
to take a challenge and to mold this definition.

Amazingly, men and women
worked with design and judgment, steel and glass,
to enact this announcement.
Here it stands.

Who can construct such miracle can enact
any consolidation, any fusion.
All little people opening out of themselves,

forging the human spirit that can outwit
big Building boasting in the cityworld.

NEW YORK SKYLINE

ABRAHAM WALKOWITZ

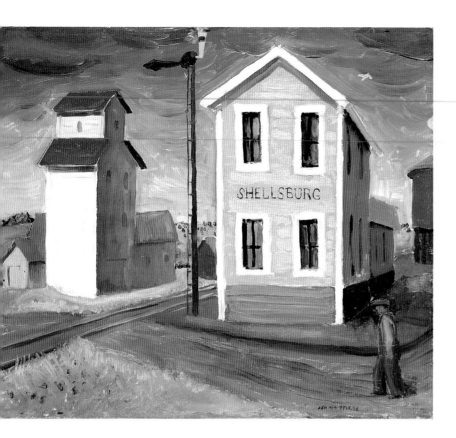

MIDWEST TOWN

RUTH DE LONG PETERSON

Farther east it wouldn't be on the map—
 Too small—but here it rates a dot and a name.
In Europe it would wear a castle cap
 Or have a cathedral rising like a flame.

But here it stands where the section roadways meet.
 Its houses dignified with trees and lawn;
The stores hold tete-a-tete across Main Street;
 The red brick school, a church—the town is gone.

America is not all traffic lights,
 And beehive homes and shops and factories;
No, there are wide green days and starry nights,
 And a great pulse beating strong in towns like these.

IOWA FARMER

MARGARET WALKER

I talked to a farmer one day in Iowa.
We looked out far over acres of wheat.
He spoke with pride and yet not boastfully;
he had no need to fumble for his words.
He knew his land and there was love for home
within the soft serene eyes of his son.
His ugly house was clean against the storm;
there was no hunger deep within the heart
nor burning riveted within the bone,
but here they ate a satisfying bread.
Yet in the Middle West where wheat was plentiful;
where grain grew golden under sunny skies
and cattle fattened through the summer heat
I could remember more familiar sights.

EVENING ON THE FARM

ORR C. FISHER

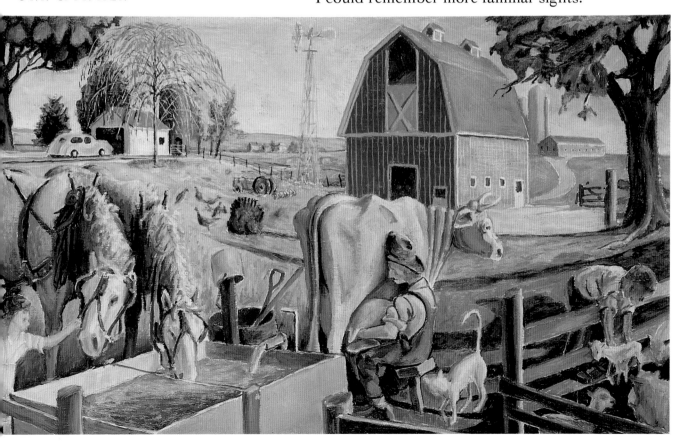

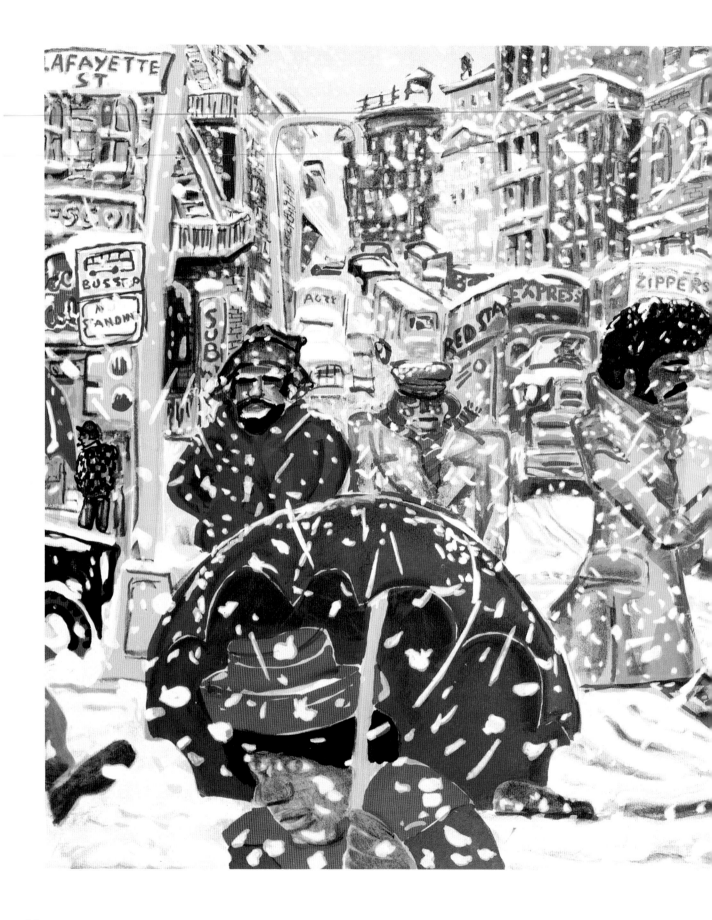

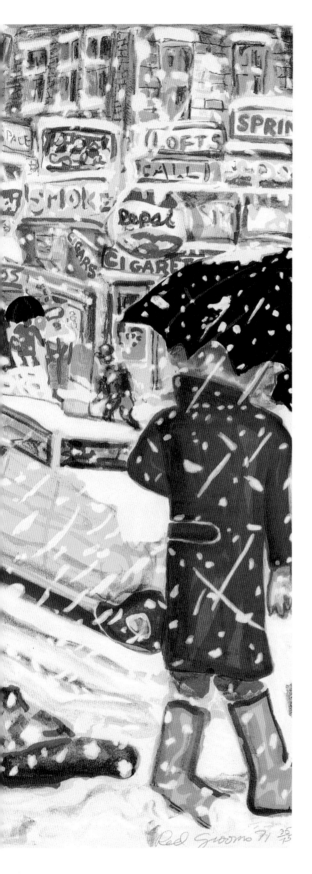

CITY TRAFFIC
EVE MERRIAM

Green as a seedling the one lane shines,
Red ripened blooms for the opposite lines;
Emerald shoot,
Vermilion fruit.

Now amber, now champagne, now honey: go slow:
Shift, settle, then gather and sow.

SLUSHING

RED GROOMS

POMONA

CARLOS CORTEZ

Like a morning ghost
The snow-capped
Gabrieles
Loom above
The palm trees and
Cottages and motels
And smog
Of the car-culture
Streets
Ever reminding
That eternity
Is NOW!

**UNTITLED,
FROM THE LOS ANGELES
DOCUMENTARY PROJECT**

DOUGLAS HILL

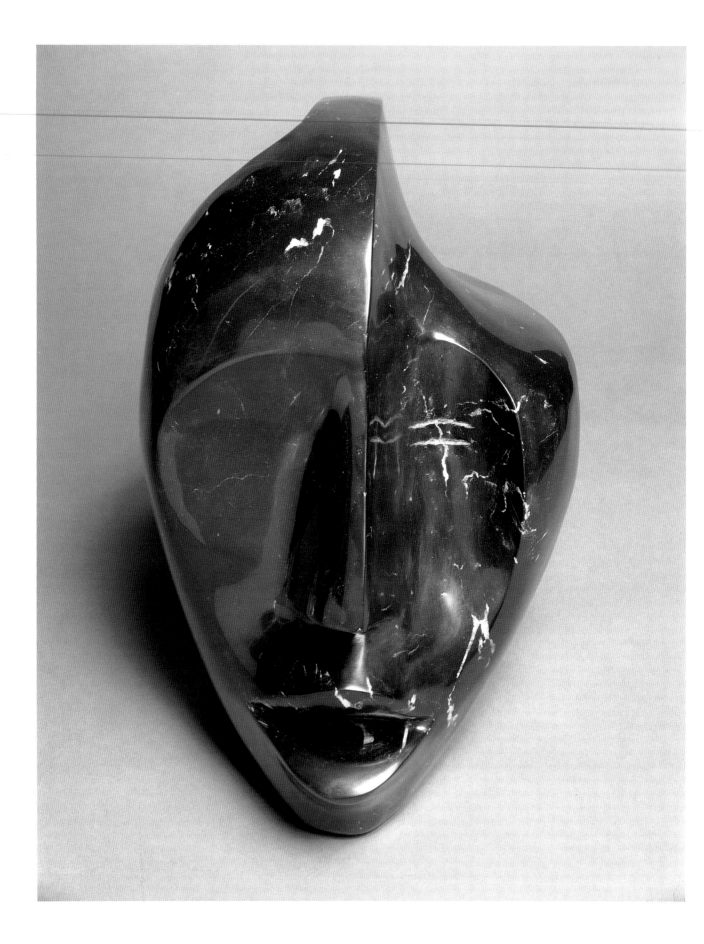

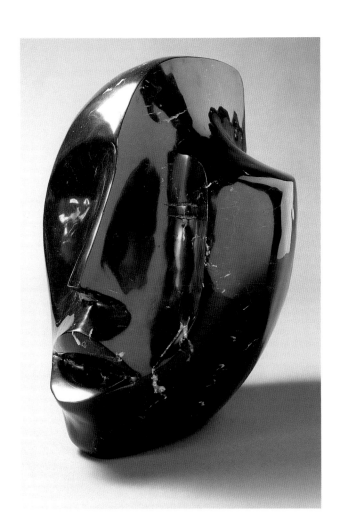

LIFT
EVERY
VOICE

SINGING HEAD

ELIZABETH CATLETT

PREAMBLE TO THE CONSTITUTION OF THE UNITED STATES

We, the people of the United States, in order to form a more perfect union, establish justice, insure domestic tranquillity, provide for the common defence, promote the general welfare, and secure the blessings of liberty to ourselves and our posterity, do ordain and establish this Constitution for the United States of America.

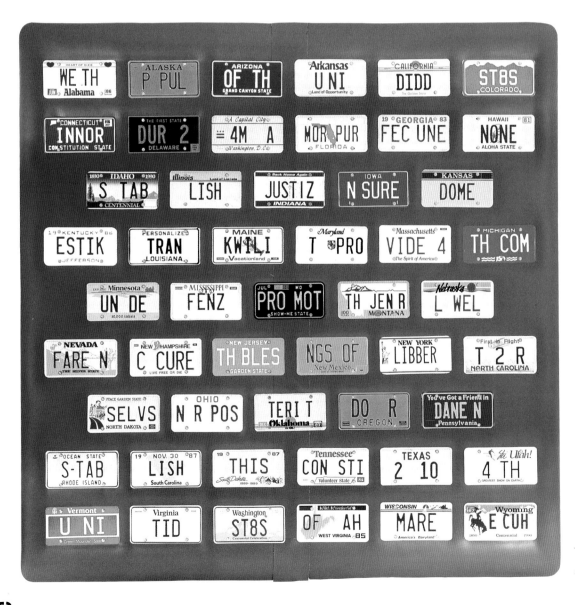

PREAMBLE

MIKE WILKINS

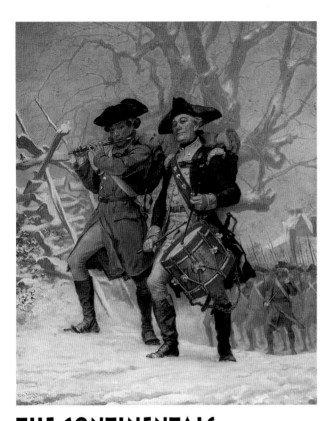

THE CONTINENTALS

FRANK BLACKWELL MAYER

OUR FATHERS FOUGHT FOR LIBERTY

JAMES RUSSELL LOWELL

Our fathers fought for liberty,
They struggled long and well,
History of their deeds can tell —
But did they leave us free?

Are we free to speak our thought,
To be happy and be poor,
Free to enter Heaven's door,
To live and labor as we ought?

Are we then made free at last
From the fear of what men say.
Free to reverence today,
Free from the slavery of the past?

Our fathers fought for liberty,
They struggled long and well,
History of their deeds can tell —
But *ourselves* must set us free.

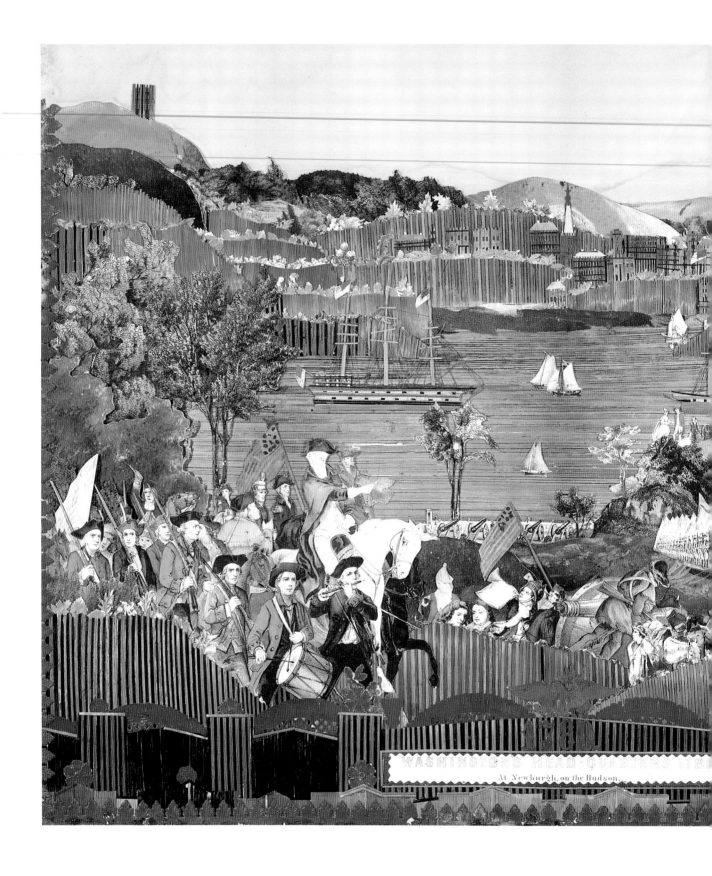

WASHINGTON'S HEAD-QUARTERS 1780

At Newburgh, on the Hudson.

CONCORD HYMN

RALPH WALDO EMERSON

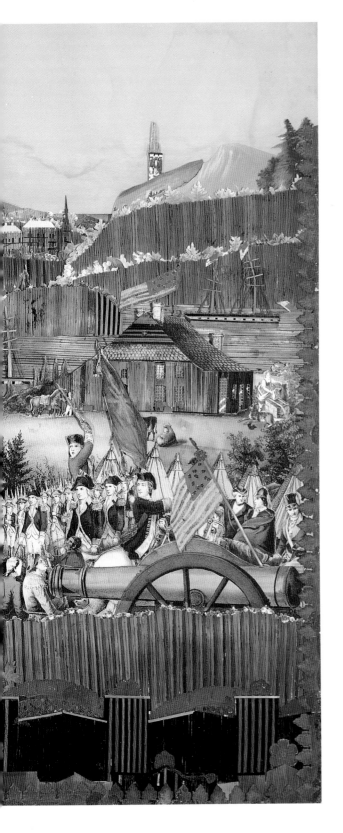

By the rude bridge that arched the flood,
 Their flag to April's breeze unfurled,
Here once the embattled farmers stood,
 And fired the shot heard round the world.

The foe long since in silence slept;
 Alike the conqueror silent sleeps;
And Time the ruined bridge has swept
 Down the dark stream which seaward creeps.

On the green bank, by this soft stream,
 We set today a votive stone;
That memory may their deed redeem,
 When, like our sires, our sons are gone.

Spirit, that made those spirits dare
 To die, and leave their children free,
Bid Time and Nature gently spare
 The shaft we raise to them and thee.

**WASHINGTON'S HEADQUARTERS
AT NEWBURGH ON
THE HUDSON IN 1780**

UNKNOWN ARTIST

LIFT EVERY VOICE AND SING

JAMES WELDON JOHNSON

Lift every voice and sing
Till earth and heaven ring,
Ring with the harmonies of liberty.
Let our rejoicing rise
High as the list'ning skies;
Let it resound loud as the rolling sea.
Sing a song full of the faith that the dark
 past has taught us;
Sing a song full of the hope that the present
 has brought us;
Facing the rising sun
Of our new day begun,
Let us march on, till victory is won.

Stony the road we trod,
Bitter the chast'ning rod,
Felt in the days when hope unborn had died;
Yet, with a steady beat,
Have not our weary feet
Come to the place for which our parents
 sighed?
We have come over a way that with tears
 has been watered;
We have come, treading our path through
 the blood of the slaughtered,
Out from the gloomy past,
Till now we stand at last
Where the white gleam of our bright star is cast.

God of our weary years,
God of our silent tears,
Thou who hast brought us thus far on the way;
Thou who hast by thy might
Led us into the light:
Keep us forever in the path, we pray.
Lest our feet stray from the places, our God,
 where we met thee;
Lest, our hearts drunk with the wine
 of the world, we forget thee;
Shadowed beneath thy hand,
May we forever stand.
True to our God, true to our native land.

CHURCH, SPROTT, ALABAMA (detail)

BILL CHRISTENBERRY, JR.

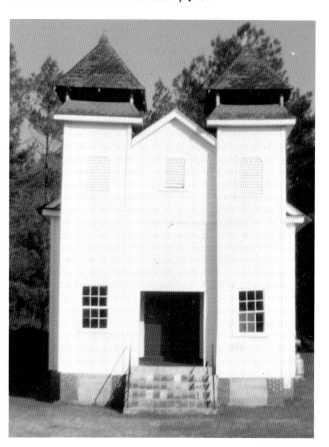

A POEM FOR MYSELF
(OR BLUES FOR A MISSISSIPPI BLACK BOY)

ETHERIDGE KNIGHT

I was born in Mississippi;
I walked barefooted thru the mud.
Born black in Mississippi,
Walked barefooted thru the mud.
But, when I reached the age of twelve
I left that place for good.
Said my daddy chopped cotton
and he drank his liquor straight.
When I left that Sunday morning
He was leaning on the barnyard gate.
Left her standing in the yard
With the sun shining in her eyes.
And I headed North
As straight as the Wild Goose Flies,
I been to Detroit & Chicago
Been to New York city too.
I been to Detroit & Chicago
Been to New York city too.
Said I done strolled all those funky avenues
I'm still the same old black boy
 with the same old blues.
Going back to Mississippi
This time to stay for good
Going back to Mississippi
This time to stay for good—
Gonna be free in Mississippi
Or dead in the Mississippi mud.

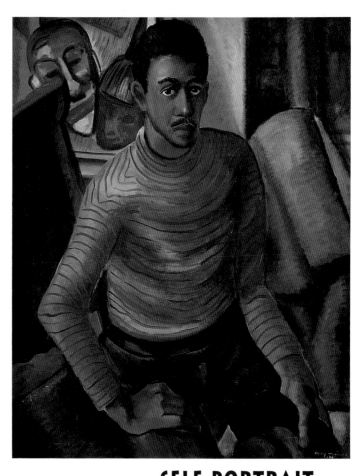

SELF-PORTRAIT

MALVIN GRAY JOHNSON

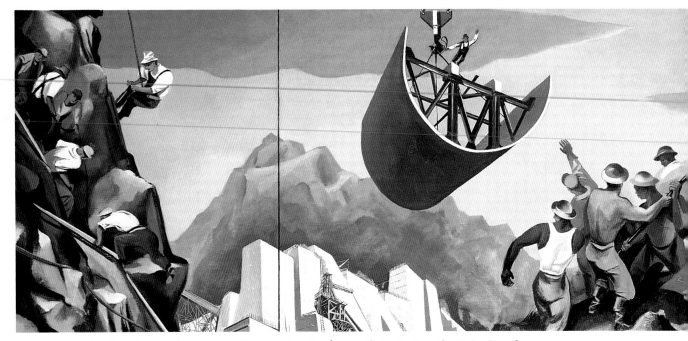

I HEAR AMERICA SINGING

WALT WHITMAN

I hear America singing, the varied carols I hear:
Those of mechanics—each one singing his, as it should be,
blithe and strong;
The carpenter singing his, as he measures his plank or beam,
The mason singing his, as he makes ready for work, or
leaves off work;
The boatman singing what belongs to him in his boat—the
deckhand singing on the steamboat deck;
The shoemaker singing as he sits on his bench—the hatter
singing as he stands;
The wood cutter's song—the ploughboy's on his way in the
morning, or at noon intermission, or at sundown;
The delicious singing of the mother—or of the young wife
at work—or of the girl sewing or washing—
Each singing what belongs to him or her and to none else;
The day what belongs to the day—at night, the party of
young fellows, robust, friendly,
Singing, with open mouths, their strong melodious songs.

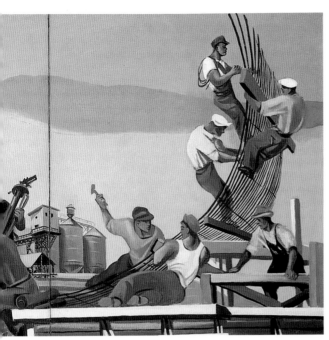

CONSTRUCTION OF THE DAM

WILLIAM GROPPER

I, TOO

LANGSTON HUGHES

I, too, sing America.

I am the darker brother.
They send me to eat in the kitchen
When company comes,
But I laugh,
And eat well,
And grow strong.

Tomorrow,
I'll sit at the table
When company comes.
Nobody'll dare
Say to me,
"Eat in the kitchen,"
Then.

Besides,
They'll see how beautiful I am
And be ashamed—

I, too, am America.

SONNET TO NEGRO SOLDIERS

JOSEPH SEAMAN COTTER, JR.

They shall go down unto Life's Borderland,
 Walk unafraid within that Living Hell,
 Nor heed the driving rain of shot and shell
That round them falls; but with uplifted hand
Be one with mighty hosts, an armed band
 Against man's wrong to man—for such full well
 They know. And from their trembling lips shall swell
A song of hope the world can understand.
All this to them shall be a glorious sign,
 A glimmer of that resurrection morn
When age-long faith, crowned with a grace benign,
 Shall rise and from their brows cast down the thorn
Of prejudice. E'en though through blood it be,
There breaks this day their dawn of liberty.

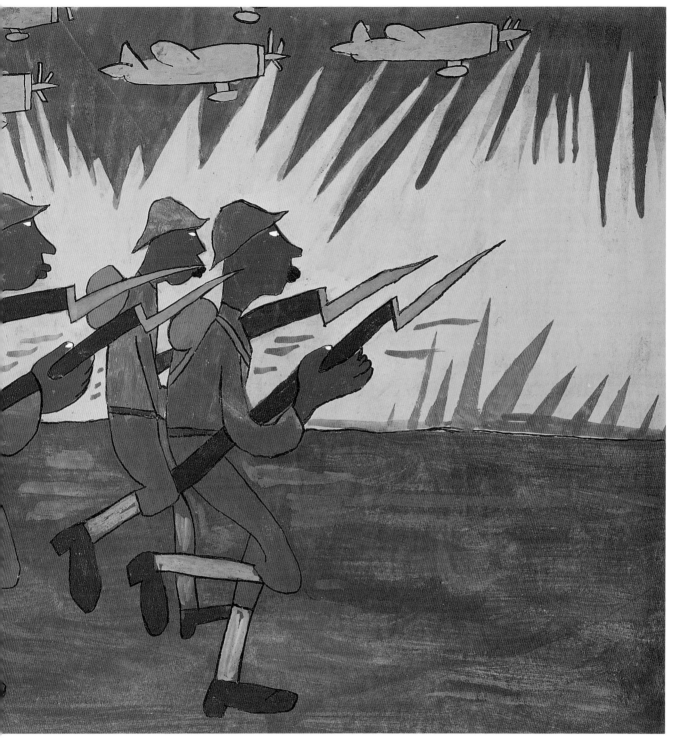

UNDER FIRE

WILLIAM H. JOHNSON

IN RESPONSE TO EXECUTIVE ORDER 9066
ALL AMERICANS OF JAPANESE DESCENT MUST REPORT TO RELOCATION CENTERS

DWIGHT OKITA

Dear Sirs:
Of course I'll come. I've packed my galoshes
and three packets of tomato seeds. Denise calls them
love apples. My father says where we're going
they won't grow.

I am a fourteen-year-old girl with bad spelling
and a messy room. If it helps any, I will tell you
I have always felt funny using chopsticks
and my favorite food is hot dogs.
My best friend is a white girl named Denise—
we look at boys together. She sat in front of me
all through grade school because of our names:
O'Connor, Ozawa. I know the back of Denise's head
 very well.

I tell her she's going bald. She tells me I copy on tests.
We are best friends.

I saw Denise today in Geography class.
She was sitting on the other side of the room.
"You're trying to start a war," she said, "giving secrets
away to the Enemy, Why can't you keep your big
mouth shut?"

I didn't know what to say.
I gave her a packet of tomato seeds
and asked her to plant them for me, told her
when the first tomato ripened
she'd miss me.

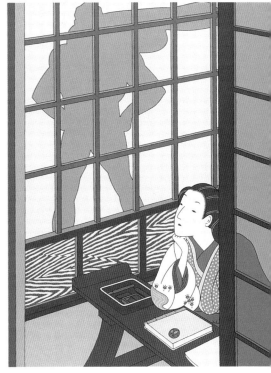

DIARY, DECEMBER 12, 194
(detail)

ROGER SHIMOMURA

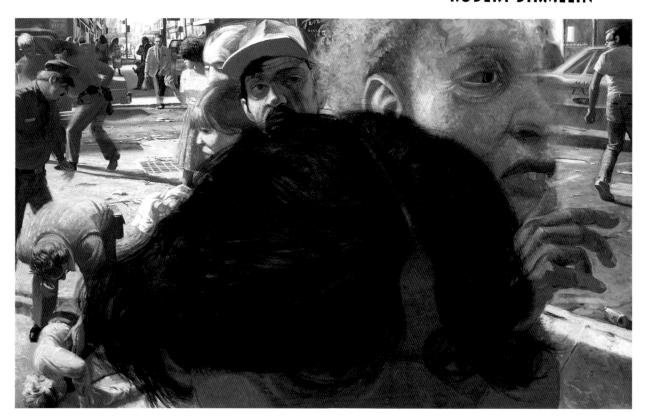

I WENT AMONG THE MEAN STREETS

MARK VAN DOREN

I went among the mean streets
Of such a city
As should have moved my wrath;
But it was pity.

I did not count the sad eyes,
They were so many.
I listened for the singing;
There was not any.

O thieves of joy, O thoughtless
Who blink at this,
Beware. There will be judgment,
With witnesses.

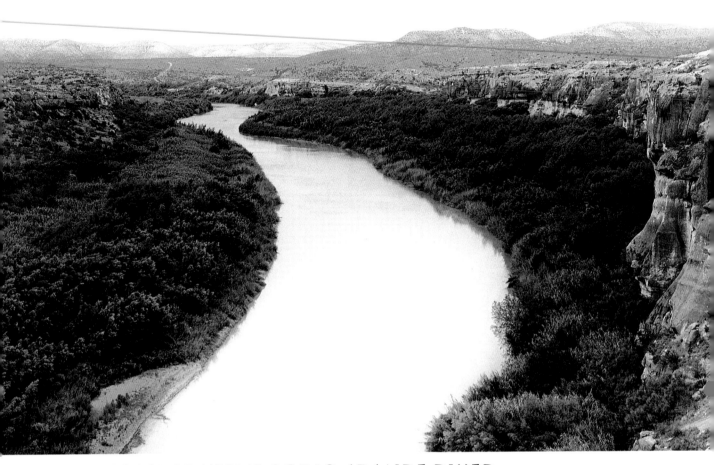

"BEST GENERAL VIEW" OF RIO GRANDE RIVER LOOKING WEST AT PUMP CANYON

PETER GOIN

TO LIVE IN THE BORDERLANDS MEANS YOU

GLORIA ANZALDÚA

[To live in the Borderlands means you]
are neither *hispana india negra española*
ni gabacha, eres mestiza, mulata, half-breed
caught in the crossfire between camps
while carrying all five races on your back
not knowing which side to turn to, run from;

To live in the Borderlands means knowing
 that the *india* in you,
 betrayed for 500 years,
 is no longer speaking to you,
 that *mexicanas* call you *rajetas,*
 that denying the Anglo inside you
 is as bad as having denied
 the Indian or Black;

Cuando vives en la frontera
 people walk through you, the wind
 steals your voice,
 you're a *burra, buey,* scapegoat,
 forerunner of a new race,
 half and half—both woman and man,
 neither—
 a new gender;

To live in the Borderlands means to
 put *chile* in the borscht,
 eat whole wheat *tortillas,*
 speak Tex-Mex with a Brooklyn accent;
 be stopped by *la migra* at the border checkpoints;

Living in the Borderlands means you fight hard to
 resist the gold elixir beckoning from the bottle,
 the pull of the gun barrel,
 the rope crushing the hollow of your throat;

In the Borderlands
 you are the battleground
 where enemies are kin to each other;
 you are at home, a stranger,
 the border disputes have been settled
 the volley of shots have shattered the truce
 you are wounded, lost in action
 dead, fighting back;

To live in the Borderlands means
 the mill with the razor white teeth wants
 to shred off
 your olive-red skin, crush out the kernel,
 your heart
 pound you pinch you roll you out
 smelling like white bread but dead;

To survive the Borderlands
 you must live *sin fronteras*
 be a crossroads.

gabacha—a Chicano term for a white woman
rajetas—literally, "split," that is, having betrayed your word
burra—donkey
buey—oxen
sin fronteras—without borders

"CIVILIZATION IS
A METHOD OF LIVING,
AN ATTITUDE OF EQUAL
RESPECT FOR ALL MEN."
—JANE ADDAMS, 1933

GEORGE GIUSTI

from
ON THE PULSE OF MORNING

MAYA ANGELOU

Women, children, men,
Take it into the palms of your hands,
Mold it into the shape of your most
Private need. Sculpt it into
The image of your most public self.
Lift up your hearts
Each new hour holds new chances
For a new beginning.
Do not be wedded forever
To fear, yoked eternally
To brutishness.

The horizon leans forward,
Offering you space
To place new steps of change
Here, on the pulse of this fine day
You may have the courage
To look up and out and upon me,
The Rock, the River, the Tree, your country.
No less to Midas than the mendicant.
No less to you now than the mastodon then.

Here on the pulse of this new day
You may have the grace to look up and out
And into your sister's eyes,
And into your brother's face,
Your country,
And say simply
Very simply
With hope —
Good morning.

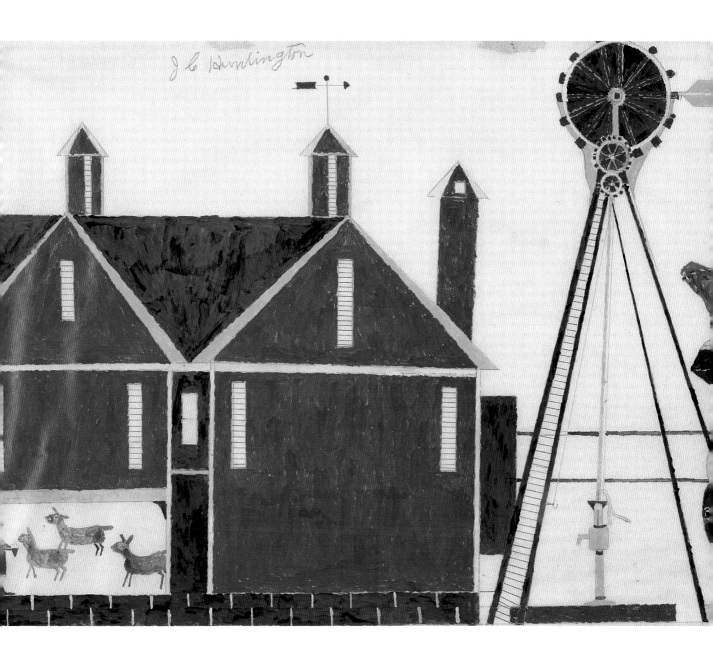

TIMELESS IS THE WHEEL

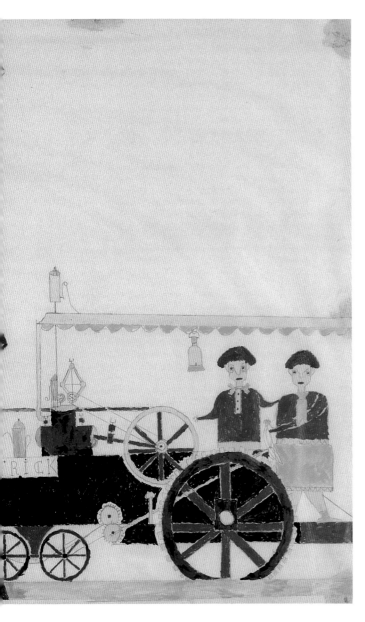

FARM SCENE (detail)

J. C. HUNTINGTON

anyone lived in a pretty how town

e. e. cummings

anyone lived in a pretty how town
(with up so floating many bells down)
spring summer autumn winter
he sang his didn't he danced his did.

Women and men (both little and small)
cared for anyone not at all
they sowed their isn't they reaped their same
sun moon stars rain

children guessed (but only a few
and down they forgot as up they grew
autumn winter spring summer)
that noone loved him more by more

when by now and tree by leaf
she laughed his joy she cried his grief
bird by snow and stir by still
anyone's any was all to her

someones married their everyones
laughed their cryings and did their dance
(sleep wake hope and then) they
said their nevers they slept their dream

stars rain sun moon
(and only the snow can begin to explain
how children are apt to forget to remember
with up so floating many bells down)

one day anyone died i guess
(and noone stooped to kiss his face)
busy folk buried them side by side
little by little and was by was

all by all and deep by deep
and more by more they dream their sleep
noone and anyone earth by april
wish by spirit and if by yes.

Women and men (both dong and ding)
summer autumn winter spring
reaped their sowing and went their came
sun moon stars rain

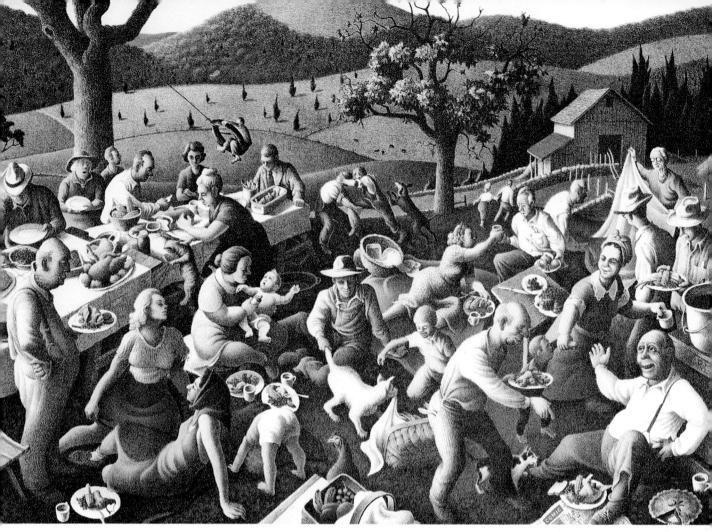

FAMILY REUNION

ROGER MEDEARIS

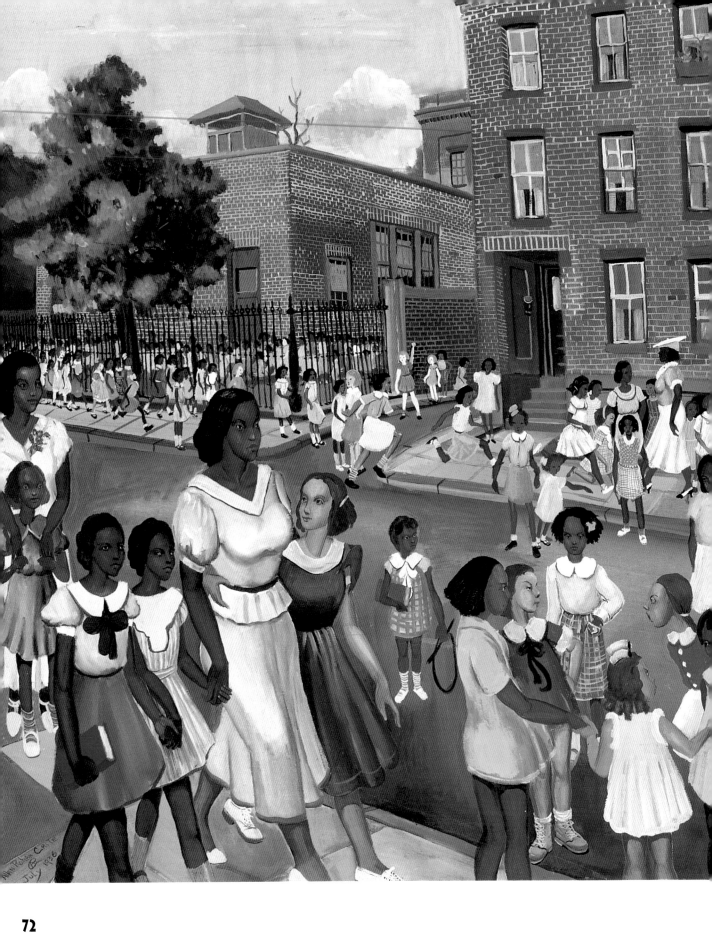

RAISING MY HAND

ANTLER

One of the first things we learn in school is
 if we know the answer to a question
We must raise our hand and be called on
 before we can speak.
How strange it seemed to me then,
 raising my hand to be called on,
How at first I just blurted out,
 but that was not permitted.

How often I knew the answer
And the teacher (knowing I knew)
Called on others I knew (and she knew)
 had it wrong!
How I'd stretch my arm
 as if it would break free
 and shoot through the roof
 like a rocket!

How I'd wave and groan and sigh,
Even hold up my aching arm
 with my other hand
Begging to be called on,
Please, *me*, I know the answer!
Almost leaping from my seat
 hoping to hear my name.

Twenty-nine now, alone in the wilds,
Seated on some rocky outcrop
 under all the stars,
I find myself raising my hand
 as I did in first grade
Mimicking the excitement
 and expectancy felt then,
No one calls on me
 but the wind.

SCHOOL'S OUT (detail)

ALLAN ROHAN CRITE

THE WHEEL

WENDELL BERRY

For Robert Penn Warren

At the first strokes of the fiddle bow
the dancers rise from their seats.
The dance begins to shape itself
in the crowd, as couples join,
and couples join couples, their movement
together lightening their feet.
They move in the ancient circle
of the dance. The dance and the song
call each other into being. Soon
they are one—rapt in a single
rapture, so that even the night
has its clarity, and time
is the wheel that brings it round.
In this rapture the dead return.
Sorrow is gone from them.
They are light. They step
into the steps of the living
and turn with them in the dance
in the sweet enclosure
of the song, and timeless
is the wheel that brings it round.

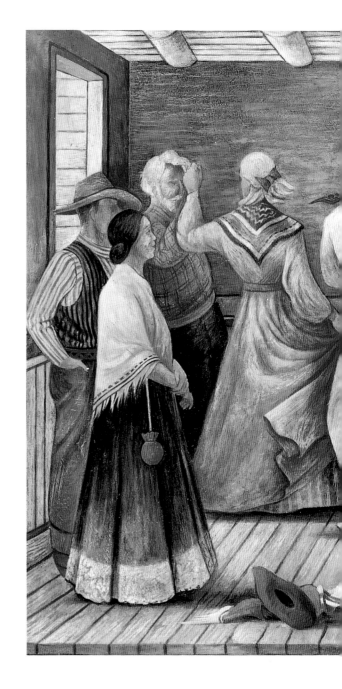

COWBOY DANCE/
FIESTA DE VAQUEROS

JENNE MAGAFAN

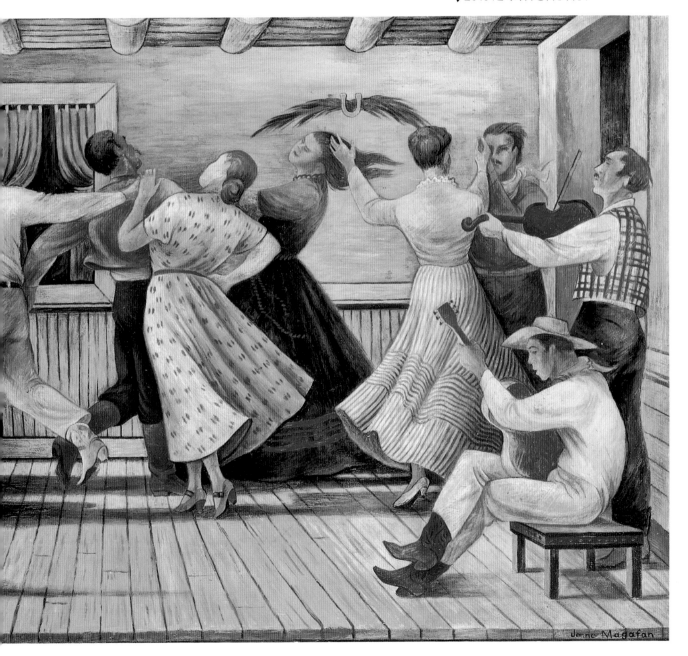

A LAZY DAY

PAUL LAURENCE DUNBAR

The trees bend down along the stream,
 Where anchored swings my tiny boat.
The day is one to drowse and dream
 And list the thrush's throttling note.
When music from his bosom bleeds
Among the river's rustling reeds.

No ripple stirs the placid pool,
 When my adventurous line is cast,
A truce to sport, while clear and cool,
 The mirrored clouds slide softly past.
The sky gives back a blue divine,
And all the world's wide wealth is mine.

A pickerel leaps, a bow of light,
The minnows shine from side to side.
The first faint breeze comes up the tide—
I pause with half uplifted oar,
While night drifts down to claim the shore.

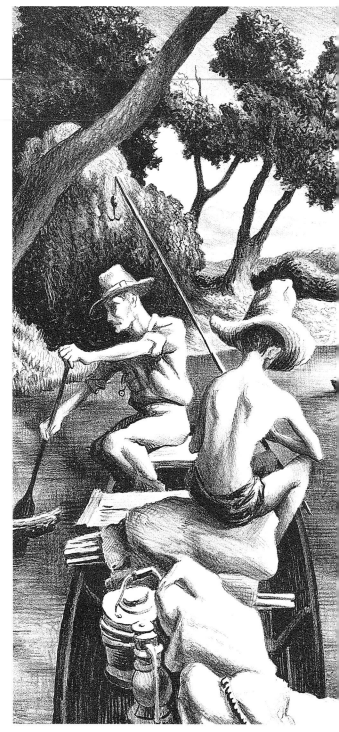

**DOWN THE RIVER
(THE YOUNG FISHERMAN)** (detail)

THOMAS HART BENTON

SANTO DOMINGO CORN DANCE
SANTO DOMINGO PUEBLO, NEW MEXICO

R. P. DICKEY

Each beat of the drum's a round drop of rain,
the stamping of the dancers' feet is rain,
their heartbeats and breathing resound as rain,
the fringes on the men's moccasins are rain,
their feathers are iridescent sheets of rain,
the toes of the barefooted females are rain,
the women's hair runs thick with black streams of rain,
the billions of motes of dust underfoot are rain,
the chunks of turquoise a lighter shade of rain
than each needle in hundreds of evergreen sprigs,
the links and clasps and rings of silver are rain,
the ghostly Koshares' antic movements are rain,
even the billions of beams from the sun become rain,
and then the actual rain, onto the earth,
for the corn, O always the actual rain,
there it comes, then it comes, and it comes.

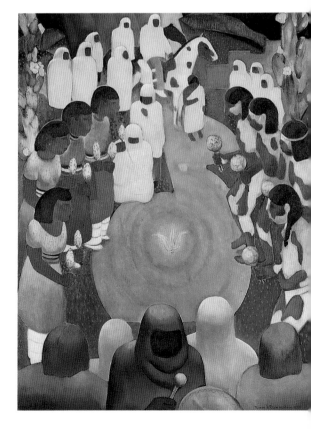

CORN DANCE, TAOS PUEBLO

NORMAN CHAMBERLAIN

KNOXVILLE, TENNESSEE

NIKKI GIOVANNI

I always like summer
best
you can eat fresh corn
from daddy's garden
and okra
and greens
and cabbage
and lots of
barbecue
and buttermilk
and homemade ice-cream
at the church picnic
and listen to
gospel music
outside
at the church
homecoming
and go to the mountains with
your grandmother
and go barefooted
and be warm
all the time
not only when you go to bed
and sleep

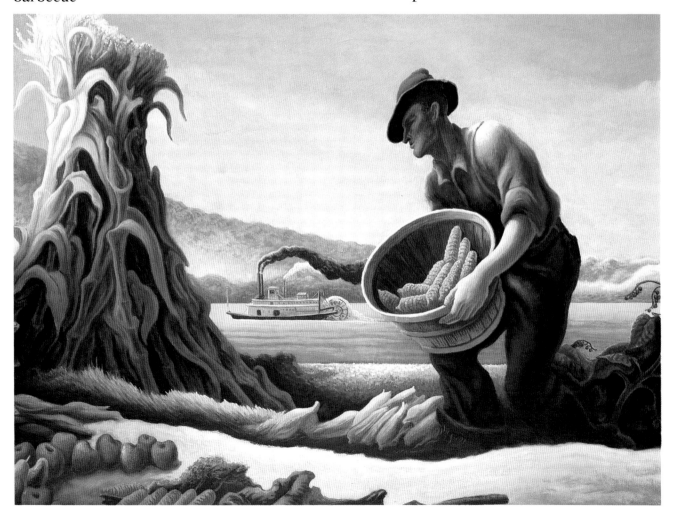

COMIDA/FOOD

VICTOR M. VALLE

Uno se come
la luna en la tortilla
Comes frijol
y comes tierra
Comes chile
y comes sol y fuego
Bebes agua
y bebes cielo

One eats
the moon in a tortilla
Eat frijoles
and you eat the earth
Eat chile
and you eat sun and fire
Drink water
and you drink sky

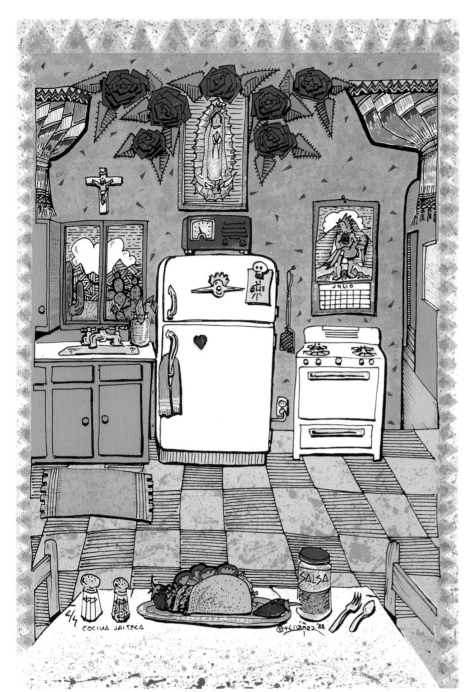

COCINA JAITECA

LARRY YÁÑEZ

ACHELOUS AND HERCULES (detail)

THOMAS HART BENTON

CONEY

VIRGINIA SCHONBORG

There's hot corn
And franks.
There's the boardwalk
With lots of games,
With chances
To win or lose.
There's the sun.
Underneath the boardwalk
It's cool,
And the sand is salty.

The beach is
Like a fruitstand of people,
Big and little,
Red and white,
Brown and yellow.
There's the sea
With high green waves.
And after,
There's hot corn
And franks.

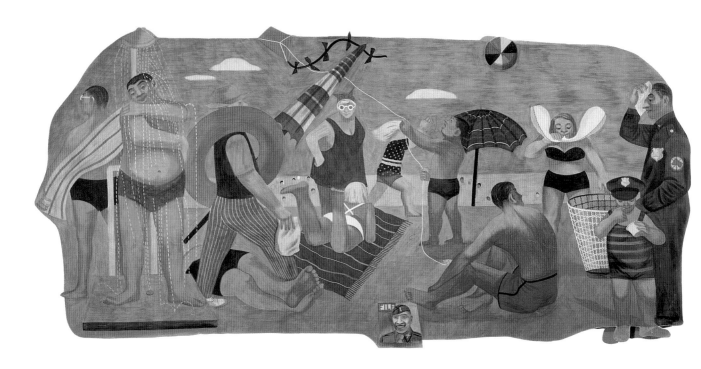

SCENES OF AMERICAN LIFE (BEACH)

GERTRUDE GOODRICH

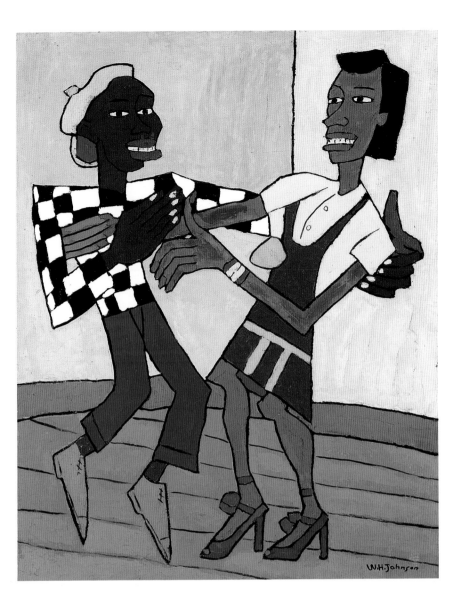

JITTERBUGS I

WILLIAM H. JOHNSON

JUKE BOX
LOVE SONG

LANGSTON HUGHES

I could take the Harlem night
and wrap around you,
Take the neon lights and make a crown,
Take the Lenox Avenue buses,
Taxis, subways,
And for your love song tone their rumble down.

Take Harlem's heartbeat,
Make a drumbeat,
Put it on a record, let it whirl,
And while we listen to it play,
Dance with you till day —
Dance with you, my sweet brown Harlem girl.

ANALYSIS OF BASEBALL

MAY SWENSON

It's about
the ball,
the bat,
and the mitt.
Ball hits
bat, or it
hits mitt.
Bat doesn't
hit ball, bat
meets it.
Ball bounces
off bat, flies
air, or thuds
ground (dud)
or it
fits mitt.

Bat waits
for ball
to mate.
Ball hates
to take bat's
bait. Ball
flirts, bat's
late, don't
keep the date.
Ball goes in
(thwack) to mitt,
and goes out
(thwack) back
to mitt.

Ball fits
mitt, but
not all
the time.
Sometimes
ball gets hit
(pow) when bat
meets it,
and sails
to a place
where mitt
has to quit
in disgrace.
That's about
the bases
loaded,
about 40,000
fans exploded.

It's about
the ball,
the bat,
the mitt,
the bases
and the fans.
It's done
on a diamond,
and for fun.
It's about
home, and it's
about run.

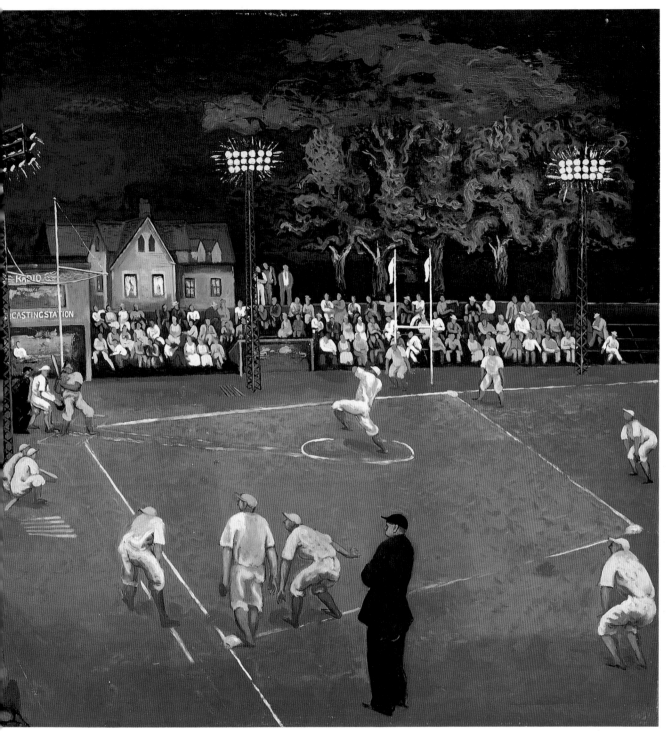

BASEBALL AT NIGHT

MORRIS KANTOR

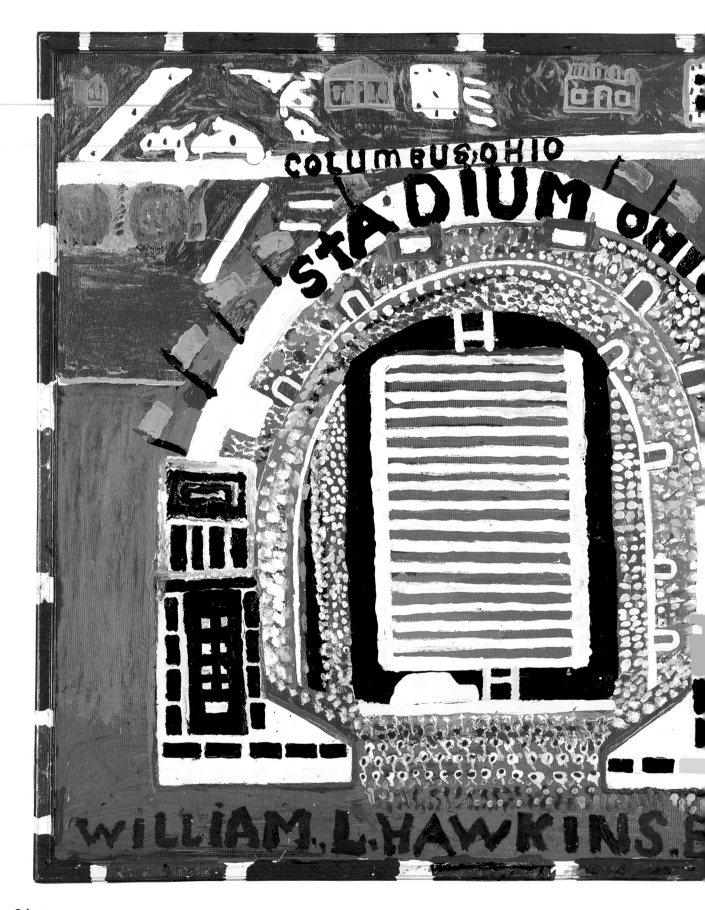

IN THE BEGINNING WAS THE

LILLIAN MORRISON

In the beginning was the

Kickoff.
The ball flew
looping down true
into the end zone
where it was snagged,
neatly hugged
by a swivel-hipped back
who ran up the field
and was smeared.

The game has begun.
The game has been won.
The game goes on.
Long live the game.
Gather and lock
tackle and block
move, move,
around the arena
and always the beautiful
trajectories.

OHIO STATE UNIVERSITY STADIUM

WILLIAM HAWKINS

SPARKLERS ON THE FOURTH

HANANIAH HARARI

THE PINTA, THE NINA AND THE SANTA MARIA; AND MANY OTHER CARGOES OF LIGHT

JOHN TAGLIABUE

America
I
carry
you
around
with
me
the
way
Buddha
carried
a
grain
of sand
the
way
Columbus
carried
a
compass
the way
Whitman
carried

a
poem
growing
expanding
like
a
galaxy
the
way
a
firefly
carries
a
galaxy
the
way
Faulkner
carries
eloquence

the
way
eloquence
carries
hope,
faith,
and
the
4th
of
July.

BIOGRAPHICAL NOTES

The following are brief biographical notes about the writers and artists whose work appears in this book. Every effort has been made to achieve accuracy, but in some cases, sources offered conflicting information about such matters as date or place of birth. In other cases, it was impossible to locate any information at all.

WRITERS

ANGELOU, MAYA (1928–) Born in Missouri. Written work includes her five-volume autobiography. At various times she has been a poet, dancer, actress, scriptwriter, director, producer, editor, and social activist. She wrote "On the Pulse of Morning" to read at the inauguration of President Bill Clinton.

ANTLER (1946–) Born in Wisconsin. A Native-American writer who has received many honors, including the Walt Whitman Award and the Wittner Bynner Prize given to "an outstanding young poet."

ANZALDÚA, GLORIA (1942–) Born in Texas. Raised in the borderlands, she is a *mestiza*, a combination of Mexican, Indian, and Anglo. Her essays, poetry, and prose are concerned with crossing the physical border between the southwestern United States and Mexico and examine psychological and spiritual borders as well. Her writings use a combination of English, Castilian Spanish, northern Mexican dialect, Tex-Mex, and Nahuatl, a Native-American dialect.

BATES, KATHARINE LEE (1859–1929) Born in Massachusetts. Author and educator who wrote "America the Beautiful" for a volume of poetry published in 1911. It later was set to music.

BENÉT, ROSEMARY (1898–1962) Born in Illinois. With her husband, Stephen, co-wrote *A Book of Americans*, which included poetic sketches of memorable figures of American history such as Johnny Appleseed, Clara Barton, and Abraham Lincoln.

BENÉT, STEPHEN VINCENT (1898–1943) Born in Pennsylvania. The author of more than sixty works, including poetry, fiction, and radio plays. Co-wrote *A Book of Americans* with his wife, Rosemary.

BERRY, WENDELL (1934–) Born in Kentucky. Writes poems, stories, magazine articles, and wry essays on farming and nature in his native state. Has won numerous awards for his poetry, including Guggenheim and Rockefeller fellowships.

BROOKS, GWENDOLYN (1917–) Born in Kansas. Began writing at the age of seven and was later encouraged by both Langston Hughes and James Weldon Johnson. Awarded the Pulitzer Prize for poetry in 1950.

CORTEZ, CARLOS (1923–) Born in Wisconsin. Role as a member of the labor union Industrial Workers of the World (IWW) has greatly influenced his writing. A poet and activist who is also well known for his powerful woodcuts and cartoons.

COTTER, JOSEPH SEAMAN, JR. (1895–1919) Born in Kentucky. Son of the well-known poet Joseph Seaman Cotter, Sr., the younger had to leave college in his second year because he contracted tuberculosis. In 1918 he published his only volume of poetry, *The Band of Gideon*.

CUMMINGS, EDWARD ESTLIN (e. e.) (1894–1962) Born in Massachusetts. Acclaimed poet of lyric energy, imagination, and verve whose work epitomized the irreverent humor and slapdash rhythms of the Jazz Age.

DICKEY, ROBERT PRESTON (R. P.) (1936–85) Born in Missouri. His ironic, self-mocking, and rebellious writings conveyed a primary theme of confronting life honestly and without pretense.

DICKINSON, EMILY (1830–86) Born in Massachusetts. Lived a secluded life. Did not write with the intent to publish, yet she is one of the most renowned poets of the English language.

DUNBAR, PAUL LAURENCE (1872–1906) Born of former slaves in Ohio. The first African-American poet to gain a national reputation in the United States. His poetry is written both in black dialect and in conventional English. Also wrote novels and short stories.

EMERSON, RALPH WALDO (1803–82) Born in Massachusetts. Poet, essayist, and philosopher whose belief in both the unlimited potential of the individual and in freedom of the spirit has been an inspiration for generations of readers.

FROST, ROBERT (1874–1963) Born in California. Author of more than thirty volumes of poetry and the recipient of many honors. He is one of America's most popular and widely read poets. Won the Pulitzer Prize in 1924, 1931, 1937, and 1943.

GARLAND, HAMLIN (1860–1940) Born in Wisconsin. Early exposure to the poverty and drudgery of farm life directed much of his writing, in which he sought to shatter the sentimental myths about rural America. Won the Pulitzer Prize for fiction in 1921.

GIOVANNI, NIKKI (1943–) Born in Tennessee. Came to national attention as a revolutionary poet of the 1960s. Later founded her own company to publish literature that speaks directly to African Americans and celebrates positive features of African-American life.

HARJO, JOY (1951–) Born in Oklahoma. A member of the Creek tribe and author of three volumes of poetry. Poetry editor for *High Plains Literary Review*.

HUGHES, LANGSTON (1902–67) Born in Missouri. An acclaimed poet, song lyricist, librettist, newspaper columnist, and playwright who not only overcame racial prejudice but also actively encouraged other African-American writers. Edited six anthologies of African-American literature.

JENNINGS, LESLIE NELSON (1890–1972) Born in Massachusetts. Primarily self-educated, a prominent writer and editor of poetry books and frequent contributor to the *New Yorker*.

JOHNSON, JAMES WELDON (1871–1938) Born in Florida. Played a vital role in the early civil rights movement of the twentieth century as poet, teacher, critic, diplomat, and NAACP official. Most often remembered as the lyricist for "Lift Every Voice and Sing," a poem referred to by many as the African-American national anthem.

KENNY, MAURICE (1929–) Born in New York. Tribal affiliation is Mohawk. His writings are characterized by their historical and spiritual depth and are shaped by the rhythms of Mohawk life and speech. His poetry book *Blackrobe* was nominated for the Pulitzer Prize in 1982.

KNIGHT, ETHERIDGE (1931–91) Born in Mississippi. Sentenced in 1960 to serve twenty years in Indiana State Prison for armed robbery. Later said, "I died in 1960 from a prison sentence and poetry brought me back to life." His books of poetry, including *Poems from Prison* (1968), have been widely read.

LAVIERA, TATO (1950–) Born in Puerto Rico. Poet, playwright, and composer whose first book, *La Carreta Made a U-Turn* (1979), is one of the most popular books of poetry by an Hispanic-American author.

LAZARUS, EMMA (1849–87) Born in New York. Poet, essayist, and champion of oppressed Jewry, best known for her sonnet "The New Colossus" (1883), inscribed on the Statue of Liberty in New York harbor.

LEE, LI-YOUNG (1957–) Born in Indonesia. Immigrated to the United States at age seven by way of Hong Kong, Macao, and Japan. His poems convey a fascination with the inarticulate—experiences that one can't talk about or express. Awarded Guggenheim and National Endowment for the Arts fellowships.

LOWELL, JAMES RUSSELL (1819–91) Born in Massachusetts. Poet, critic, editor, teacher, and diplomat, Lowell was among the most popular American writers of the nineteenth century.

MERRIAM, EVE (1916–92) Born in Pennsylvania. Poet, playwright, and lyricist who wrote more than fifty works for adults and children. Her writing ranged in theme from lighthearted verse to realistic poems on inner-city poverty.

MILLER, JOAQUIN (1837–1913) Born in Indiana. Pseudonym for Cincinnatus Hiner Miller, a lawyer who rose to fame not in America but in England, where he became a spokesman for the American West. Especially noted for his attempts to write poetry in the American vernacular.

MOMADAY, N. SCOTT (1934–) Born in Oklahoma. A member of the Kiowa tribe. Awarded the 1969 Pulitzer Prize for his novel *House Made of Dawn*.

MORRISON, LILLIAN (1917–) Born in New Jersey. For many years worked as a librarian for young people at the New York Public Library. Author of seventeen books for children, including four anthologies of sports poems.

MURTON, JESSIE WILMORE (n.d.) Born in Kentucky. Little is known about this author who published nearly one thousand poems in magazines, journals, and newspapers from the 1930s to the 1960s.

OKITA, DWIGHT (1958–) Born in Illinois. Poet and playwright, a third-generation Japanese American who wrote *Crossing with the Light*, his first book of poetry, in 1982.

OLIVER, LOUIS (LITTLE COON) (1904–91) Born in Oklahoma. Member of the Creek tribe, his ancestry is traced to the Indian clans who lived along the Chattahoochee River in Alabama. His poetry honors and maintains reverence for the natural world.

PETERSON, RUTH DE LONG (1916–) Born in Iowa. Has lived within a few miles of New London, Iowa, all her life. Work celebrates the gentle hills and prairies of the American Midwest. Served for twenty years as editor of *Lyrical Iowa*, the Iowa Poetry Association's annual, and currently is a journalist for two local newspapers.

RÍOS, ALBERTO (1952–) Born in Arizona. First book of poetry, *Whispering to Fool the Wind* (1982), chosen as winner of the 1981 Walt Whitman Award of the Academy of American Poets.

ROMERO, LEO (1950–) Born in New Mexico. Author of five volumes of poetry and owner of a small bookstore in New Mexico. Awarded Pushcart Prize from the Pushcart Press in 1982.

SANDBURG, CARL (1878–1967) Born in Illinois. Wrote poetry about the industrial cities and pastoral countryside of the American Midwest. His poems often contained a passionate concern for the common man. Famous for both his poetry and his six-volume biography of fellow Illinoisan Abraham Lincoln.

SCHONBORG, VIRGINIA (1913–91) Born in Rhode Island. Author of well-known children's books such as *The Salt Marsh* and *The Subway Singer*. Wrote frequently about urban children.

SNOW, CAROL (1950–) Born in New York. A native of the Allegheny Indian reservation in New York State. Her tribal affiliation is Seneca. A zoologist, Snow artfully depicts wildlife in her poetry and drawings.

STOUTENBERG, ADRIEN (1916–82) Born in Minnesota. Author of more than thirty books for children, her poems have also appeared in such distinguished journals as the *New Yorker*, the *Nation*, *Poetry*, and the *Yale Review*.

SWENSON, MAY (1919–89) Born in Utah. Self-taught poet whose vibrant poems of delicate humor earned her the Bollingen Poetry Award in 1981, Rockefeller and Guggenheim fellowships, and a grant from the National Endowment for the Arts.

TAGLIABUE, JOHN (1923–) Born in Italy. A U.S. citizen, he travels extensively, teaching in universities around the world. His thoughtful poems and essays include reflections on his experiences in France, England, Italy, Greece, Mexico, and Guatemala.

TOOMER, JEAN (1894–1967) Born in Washington, D.C. One of the major writers of the Harlem Renaissance. Although widely published as a poet, best known for his avant-garde novel, *Cane*, a celebration of blackness.

VALLE, VICTOR M. (1950–) Born in California. A poet, translator, editor, activist, and *Los Angeles Times* investigative reporter. "Poetry is a tool," he once wrote, "because it helps you take things apart."

VAN DOREN, MARK (1894–1972) Born in Illinois. Published more than sixty-five books, including twelve volumes of poetry. His writing records everyday events and the lessons to be learned from them.

WALKER, MARGARET (1915–) Born in Alabama. Took up writing at the age of eleven. In 1942 won the Yale Series of Younger Poets Award for *For My People*, becoming one of the youngest African-American writers to publish a volume of poetry, as well as the first African-American woman to win a prestigious national prize.

WHITMAN, WALT (1819–92) Born in New York. His *Leaves of Grass*, published in 1855 and revised frequently thereafter, brought attention to his vision of equality, national purpose, and brotherhood. His book revolutionized the techniques and subject matter of American poetry.

ARTISTS

ALQUILAR, MARIA (1935–) Born in New York. The daughter of a Russian Jewish mother and Spanish father. Her altarpieces seek to explore the mythic heritage of many cultures and expose their common threads.

ARMIN, EMIL (1883–1971) Born in Romania. Immigrated to the United States at age twenty-two. Painter known for his use of vibrant color and brushwork.

BENTON, THOMAS HART (1889–1975) Born into a famous Missouri family of politicians. His work captures the American Midwest—its people, life, and culture.

BIERSTADT, ALBERT (1830–1902) Born in Germany. Immigrated to the United States as a child. Paintings show an idealistic view of the American wilderness.

BIRMELIN, ROBERT (1933–) Born in New Jersey. Painter known for his New York crowd scenes that convey a sense of panic and urgency.

CATLETT, ELIZABETH (1919–) Born in Washington, D.C. Sculptor whose primary theme is the African-American woman, portrayed with strength, physicality, and grandeur. Known for her masklike facial sculptures that incorporate both African and Mexican features.

CATLIN, GEORGE (1796–1872) Born in Pennsylvania. Created more than two thousand paintings, drawings, and sketches of North American Indians, which are some of the earliest depictions of Native Americans and their customs by an outside artist.

CHAMBERLAIN, NORMAN (1887–1961) Born in Michigan. Muralist whose work was inspired by his visits to Taos, New Mexico, in the 1920s and 1930s.

CHRISTENBERRY, WILLIAM, JR. (1936–) Born in Alabama. An artist of national acclaim, equally known for his photographs of the South and his disturbing sculptural pieces.

CRITE, ALLAN ROHAN (1910–) Born in New Jersey. Best known for his religious illustrations; also an observer of urban African-American life in Boston during the 1930s and 1940s.

DOVE, ARTHUR G. (1880–1946) Born in New York. A pioneering abstract painter known for expressing natural forms, sounds, and musical motifs in his paintings.

DUNTON, W. HERBERT (1878–1936) Born in Maine. A painter who specialized in wildlife scenes, cowboys, and other themes of the American West.

EVANS, TERRY (1944–) Born in Missouri. Photographer of the Kansas landscape and an activist in the conservation movement.

FISHER, ORR C. (1885–n.d.) Born in Iowa. Muralist commissioned to create *Evening on the Farm* for the Forest City, Iowa, post office. His art explores the role of the farmer in local history and the nature of rural life.

GOIN, PETER (1951–) Born in Wisconsin. Well known for his photographic surveys of contemporary landscapes and a series of photographs entitled *Nuclear Landscapes*, which depict nature after nuclear explosions.

GOODRICH, GERTRUDE (1914–) Born in New York. Muralist whose art appears in federal buildings across the United States. Her work examines everyday aspects of American life.

GROOMS, RED (1937–) Born in Tennessee. Renowned artist whose lifelong fascination with the circus has filled his work with colorful, energetic figures that convey a simple sense of fun.

GROPPER, WILLIAM (1897–1977) Born in New York. Best known as a social realist and as a radical cartoonist for numerous popular magazines.

HARARI, HANANIAH (1912–) Born in New York. Has led a double life as both an abstract painter whose work has been exhibited in museums and as a commercial artist who has designed print advertisements and magazine covers.

HAWKINS, WILLIAM (1895–1990) Raised in Kentucky. Folk artist who learned to draw by copying illustrations from horse-auction announcements and calendar pictures.

HILL, DOUGLAS (1950–) Born in England. Immigrated to the United States to study photography at UCLA and the California Institute of the Arts. Photographer whose search for insight into the Southern California experience has led him to document its commonplace and often overlooked sites.

HOLMES, WILLIAM H. (1846–1933) Born in Ohio. Studied geology and archaeology in the West for fifteen years; his interest in art was primarily for illustrating his research. Later served as curator at the Smithsonian Institution, the Field Colombian Museum, and the National Gallery.

HOMER, WINSLOW (1836–1910) Born in Massachusetts. A landmark painter of the nineteenth century who often painted the ocean, streams, and rivers to capture the elemental forces of nature. During the Civil War, Homer traveled the front as a correspondent for *Harper's Weekly*, sketching scenes of the daily lives of soldiers.

HUNTINGTON, J. C. (n.d.) Lived in Sunbury, Pennsylvania. Little is known about this retired railroad worker who used his daughter as the model for the children in his folk-art paintings.

INNESS, GEORGE (1825–94) Born in New York. Landscapist whose varied styles ranged from the romantic landscapes of his youth to a more personal vision of nature expressed in the frenzied strokes and rich tones of his later years.

JENSHEL, LEN (1949–) Born in New York. Has won many awards for his photographs of American landscapes—from southwestern deserts to the palatial mansions of the East Coast. Recipient of National Endowment for the Arts and Guggenheim fellowships.

JIMÉNEZ, LUIS, JR. (1940–) Born in Texas. Creates monumental public sculptures that both celebrate and question mythic icons of his Hispanic heritage.

JOHNSON, MALVIN GRAY (1896–1934) Born in North Carolina. One of the first African-American artists to develop themes of cubism in his work.

JOHNSON, WILLIAM H. (1901–70) Born in South Carolina. Trained in a highly academic tradition, but over time his work evolved to include bright, pure colors and a deliberately "primitive" style that expressed the spirit of the African-American experience.

JOSEPHSON, KENNETH BRADLEY (1932–) Born in Michigan. Internationally known photographer and assemblage artist whose works are often commentaries on picture making because they contain images within images and force the viewer to think about what is real and what the artist has created.

KANTOR, MORRIS (1896–1974) Born in Russia. Immigrated to the United States at the age of ten. From the semi-abstract works of his early career to his later depictions of the natural world, Kantor was a vital force in American art as both an artist and as a mentor to Robert Rauschenberg and John Hultberg.

LAFARGE, JOHN (1835–1910) Born in New York. Traveled the world in search of the exotic. His artistic interests were varied—watercolors, murals, and stained glass.

LAWRENCE, JACOB (1917–) Born in New Jersey. Preeminent African-American painter and a distinguished educator whose work has wide appeal because of its colorful, abstract style and the universal nature of its subject matter.

LEHMAN, HAROLD (1913–) Born in New York. Muralist and painter whose work has been exhibited in prestigious New York museums and whose murals appeared in Riker's Island prison and a Pennsylvania post office.

LEUTZE, EMANUEL GOTTLIEB (1816–68) Born in Germany. Immigrated to the United States as a child and settled in Philadelphia, Pennsylvania. Largely known for his historical and portrait painting.

LUNDEBERG, HELEN (1908–) Born in Illinois. The artist frequently uses images of herself as an element in her art; work most often conveys a peaceful waiting, a mystical calm.

MAGAFAN, JENNE (1915–52) Born in Illinois. Primarily a muralist, the artist achieved national recognition in a brief career.

MAYER, FRANK BLACKWELL (1827–99) Born in Maryland. Known for his large collection of life studies of Native Americans and as a painter of colonial subjects.

MEDEARIS, ROGER (1920–) Born in Missouri. A map draftsman for the Naval Department during World War II. His fine draftsmanship influenced all his later works in the detail and meticulous realism of his style.

MORAN, THOMAS (1837–1926) Born in Lancashire, England. Immigrated to the United States in 1844. As an artist for the U.S. Geological Survey, he was inspired by his many expeditions to the West. A master at portraying the illusion of height, his paintings often include a perch or a precipice looking down a chasm or waterfall.

OQWA PI (Abel Sanchez) (ca. 1899–1971) A Native American from San Ildefonso Pueblo. He recognized painting as one of his talents early and pursued it, developing a style distinguished by a variety of geometric designs and bright colors.

PERLIN, BERNARD (1918–) Born in Virginia. After high school moved to New York City to study art. During World War II, he traveled the world as a newspaper sketch artist.

PYLE, ARNOLD (n.d.) Resident of Iowa. Painter who worked largely in watercolor throughout his career. Little is known about this artist who was part of the Works Progress Administration during the Great Depression in the early 1930s.

RESIDENTS OF BOURBON COUNTY, KENTUCKY (n.d.) A quilt, designed and created by residents of Paris, Kentucky, in 1893, bears the 110 names of the people who worked on it; features the fan, a common Victorian pattern, as a design element; and is a collage of hand-sewn scraps formally arranged.

RODRIGUEZ, JOSEPH (1951–) Born in New York. Photographer who captures people in the context of their culture and locale. Subjects have included the Kurdish people of southeastern Turkey, street children in Mozambique, Africa, and the everyday life of people who live in Spanish Harlem, New York.

SAVITSKY, JACK (1910–91) Born in Pennsylvania. Well known for his bright and colorful depictions of life in and around the hard-coal regions of Lansford, Pennsylvania. He drew with a variety of materials and painted in oils on all kinds of surfaces.

SHIMOMURA, ROGER (1939–) Born in Washington. Painter of Japanese descent who has been a diligent arts educator most of his life.

WALKOWITZ, ABRAHAM (1880–1965) Born in Russia. Immigrated to the United States in 1889. Avant-garde painter who experimented with different styles and subjects, incorporating realism and social issues into his work.

WILKINS, MIKE (n.d.) Born in North Carolina. Best known as a conceptual artist who celebrated the bicentennial of the U.S. Constitution by requesting personalized license plates from all fifty states to form its preamble.

YÁÑEZ, LARRY (1949–) Born in Arizona. A multi-talented artist and musician who is best known for his use of Chicano cultural symbols. The painting included in this book was also featured on the cover of an album by his band, Jackalope.

ZELDIS, MALCAH (1931–) Born in Michigan. A self-taught artist who did not begin painting until her late thirties. Famous for her folk-art paintings that reflect both urban and Jewish traditions.

LIST OF ILLUSTRATIONS

POETRY ACKNOWLEDGMENTS

Page 11: "Legacy" by Maurice Kenny from *Between Two Rivers: Selected Poems 1956–1984*, reprinted by permission of White Pine Press. **Page 13:** "In Hardwood Groves" from *The Poetry of Robert Frost*, edited by Edward Connery Lathem. Copyright 1934, © 1969 by Henry Holt and Company, Inc., Copyright © 1962 by Robert Frost. Reprinted by permission of Henry Holt and Company, Inc. **Page 14:** "Niagara" from *The People, Yes* by Carl Sandburg, copyright 1936 by Harcourt Brace & Company and renewed 1964 by Carl Sandburg, reprinted by permission of Harcourt Brace & Company. **Page 15:** "The Monoliths" by N. Scott Momaday from *The Gourd Dancer*, reprinted by permission of the author. **Page 20:** "Drumbeat" by Carol Snow, © Carol Snow—Seneca Indian Heritage. **Page 21:** "The Road to Tres Piedras" by Leo Romero, first published in *New Mexico* magazine, reprinted by permission of Leo Romero and *New Mexico* magazine. **Page 24:** "Empty Kettle" by Louis (Little Coon) Oliver, reprinted by permission of the estate of the author and the Greenfield Review Literary Center. **Page 25:** "Lineage" by Margaret Walker Alexander from *This Is My Century: New and Collected Poems*. Copyright 1989 by Margaret Walker Alexander. Published by the University of Georgia Press (Athens, Georgia). **Page 26:** "Dream Variation" by Langston Hughes from *Selected Poems* by Langston Hughes, copyright 1926 by Alfred A. Knopf, Inc. and renewed 1954 by Langston Hughes. Reprinted by permission of the publisher. **Page 28:** Li-Young Lee. "I Ask My Mother to Sing," copyright © 1986 by Li-Young Lee. Reprinted from *Rose* by Li-Young Lee, with permission of BOA Editions, Ltd., 92 Park Ave., Brockport, NY 14420. **Page 29:** "AmeRícan" by Tato Laviera is reprinted with permission from the publisher of "AmeRícan" (Houston: Arte Publico Press—University of Houston, 1985). **Pages 30–31:** "Day of the Refugios" by Alberto Ríos, © 1993 by Alberto Ríos. Reprinted by permission of the author. **Page 33:** "Remember" by Joy Harjo from the book *She Had Some Horses* by Joy Harjo. Copyright © 1983 by Joy Harjo. Used by permission of the publisher, Thunder's Mouth Press. **Page 36:** "Western Wagons" by Rosemary & Stephen Vincent Benét from: *A Book of Americans* by Rosemary & Stephen Vincent Benét. Copyright 1933 by Rosemary & Stephen Vincent Benét. Renewed © 1965 by Thomas C. Benét, Stephanie Mahin. Reprinted by permission of Brandt & Brandt Literary Agents, Inc. **Page 41:** "Assembly Line" by Adrien Stoutenberg, reprinted by permission of Curtis Brown, Ltd. Copyright © 1964 by Adrien Stoutenberg; copyright © 1992 renewed by Laura Nelson Baker. **Page 43:** "Building" by Gwendolyn Brooks from *The Near-Johannesburg Boy*, 1987. © 1991 by Gwendolyn Brooks (reissued by Third World Press, Chicago). **Page 44:** "Midwest Town" by Ruth De Long Peterson. Reprinted with permission from the *Saturday Evening Post* © 1954. **Page 45:** "Iowa Farmer" by Margaret Walker Alexander from *This Is My Century: New and Collected Poems*—University of Georgia Press (Athens, Georgia), 1989. **Page 47:** "City Traffic" by Eve Merriam from *It Doesn't Always Have to Rhyme* by Eve Merriam. Copyright © 1964 by Eve Merriam. © renewed 1992 by Eve Merriam. Reprinted by permission of Marian Reiner. **Page 48:** "Pomona" by Carlos Cortez, reprinted by permission of Carlos Cortez, courtesy MARCH/Abrazo Press. **Page 56:** "Lift Every Voice and Sing"—James Weldon Johnson, J. Rosamond Johnson. Used by permission of Edward B. Marks Music Company. **Page 57:** "Song for Myself" is reprinted from *The Essential Etheridge Knight*, by Etheridge Knight, by permission of the University of Pittsburgh Press. © 1986 by Etheridge Knight. **Page 59:** "I, Too" by Langston Hughes from *Selected Poems* by Langston Hughes, copyright 1926 by Alfred A. Knopf, Inc. and renewed 1954 by Langston Hughes. Reprinted by permission of the publisher. **Page 62:** "In Response to Executive Order 9066" copyright © 1983 by Dwight Okita, from *Crossing with the Light* by Dwight Okita (Tia Chucha Press, Chicago, 1992). **Page 63:** "I Went Among the Mean Streets" from *100 Poems* by Mark Van Doren. Copyright © 1967 by Mark Van Doren. Reprinted by permission of Hill & Wang, a division of Farrar, Straus & Giroux, Inc. **Page 65:** "To live in the Borderlands means you" by Gloria Anzaldúa from *Borderlands/La Frontera: The New Mestiza* © 1987 by Gloria Anzaldúa. Reprinted with permission from Aunt Lute Books, (415) 558-8116. **Page 67:** From "On the Pulse of Morning" by Maya Angelou. Copyright © 1993 by Maya Angelou. Reprinted by permission of Random House, Inc. **Page 70:** "anyone lived in a pretty how town" is reprinted from *Complete Poems, 1904–1962*, by E. E. Cummings. Edited by George J. Firmage, by permission of Liveright Publishing Corporation. Copyright © 1923, 1925, 1926, 1931, 1935, 1938, 1939, 1940, 1944, 1945, 1946, 1947, 1948, 1949, 1950, 1951, 1952, 1953, 1954, 1955, 1956, 1957, 1958, 1959, 1960, 1961, 1962 by E. E. Cummings. Copyright © 1961, 1963, 1966, 1967, 1968 by Marion Morehouse Cummings. Copyright © 1972, 1973, 1974, 1975, 1976, 1977, 1978, 1979, 1980, 1981, 1982, 1983, 1984, 1985, 1986, 1987, 1988, 1989, 1990, 1991 by the Trustees for the E. E. Cummings Trust. **Page 73:** "Raising My Hand" copyright 1986 by Antler: reprinted from *An Ear to the Ground: An Anthology of Contemporary American Poetry* with permission by the University of Georgia Press. **Page 74:** "The Wheel" from *The Wheel* by Wendell Berry. Copyright © 1982 by Wendell Berry. Reprinted by permission of North Point Press, a division of Farrar, Straus & Giroux, Inc. **Page 78:** "Knoxville, Tennessee" from *Black Feeling, Black Talk, Black Judgment* by Nikki Giovanni. Copyright © 1968, 1970 by Nikki Giovanni. Reprinted by permission of William Morrow & Company, Inc. **Page 79:** "Comida/Food" by Victor Valle from *Fiesta in Aztlan*. Reprinted by permission of the Capra Press. **Page 80:** "Coney" from *Subway Swinger* by Virginia Schonborg. Copyright © 1970 by Virginia Schonborg. Reprinted by permission of Morrow Junior Books, a division of William Morrow & Company, Inc. **Page 81:** "Juke Box Love Song" by Langston Hughes from *Selected Poems* by Langston Hughes. Reprinted by permission of Harold Ober Associates Incorporated. Copyright 1951 by Langston Hughes. Copyright renewed 1979 by George Houston Bass. **Page 82:** "Analysis of Baseball" by May Swenson © 1971. Used with permission of the Literary Estate of May Swenson. **Page 85:** "In the beginning was the" by Lillian Morrison from *Sprints & Distances* by Lillian Morrison. Copyright © 1965 by Lillian Morrison. Reprinted by permission of Marian Reiner for the author. **Page 87:** "The Pinta, the Nina and the Santa Maria; and Many Other Cargoes of Light" by John Tagliabue from *A Japanese Journal* by John Tagliabue. Reprinted from *Prairie Schooner* by permission of the University of Nebraska Press. Copyright © 1963 University of Nebraska Press.

POETRY ACKNOWLEDGMENTS (PAPERBACK EDITION)

Page 26: "Dream Variation" by Langston Hughes from *Collected Poems* by Langston Hughes. Copyright © 1994 by the Estate of Langston Hughes. Reprinted by permission of Alfred A. Knopf, Inc. **Page 43:** "Building" by Gwendolyn Brooks from *The Near-Johannesburg Boy*, published by Third World Press. Copyright © 1991 by Gwendolyn Brooks. **Page 59:** "I, Too" by Langston Hughes from *Collected Poems* by Langston Hughes. Copyright © 1994 by the Estate of Langston Hughes. Reprinted by permission of Alfred A. Knopf, Inc.

INDEX